HEART OF

*The evolution of the New Era rests on the
cornerstone of Knowledge and Beauty.*

—Nicholas Roerich

HEART OF

Asia

Memoirs from the Himalayas

❖ ❖ ❖

NICHOLAS ROERICH

INNER TRADITIONS INTERNATIONAL
ROCHESTER, VERMONT

Inner Traditions International, Ltd.
One Park Street
Rochester, Vermont 05767

Copyright © 1990 by the Nicholas Roerich Museum
First published in 1929 by Roerich Museum Press

Library of Congress Cataloging-in-Publication Data

Rerikh, Nikolaĭ Konstantinovich, 1874-1947.
 Heart of Asia / Nicholas Roerich.
 p. cm.
 First published in 1929 by Roerich Museum Press--T.p. verso.
 ISBN 0-89281-302-4
 1. Asia, Central--Description and travel. 2. Asia, Central--Religion. I. Title.
 DS327.7.R46 1990
 958--dc20 90-43826
 CIP

Printed and bound in the United States.

10 9 8 7 6 5 4 3 2 1

Disibuted to the book trade in the United States by American International
 Distribution Corporation (AIDC), Colchester, Vermont

Distributed to the book trade in Canada by Book Center, Inc., Montreal,
 Quebec

CONTENTS

FOREWORD

Nicholas Roerich was fond of saying, "Blessed be the obstacles—through them we grow." He was well qualified to know, for obstacles were a constant in his life. A superficial glance at his life would reveal only creativity and adventure, far more than is generally allotted to any one person in a lifetime. But beneath that surface lay ever-present difficulty.

It is hard to know why certain people are given greater portions of trouble than others. Roerich came from privileged people, and his life could have been easy. But Russians in this century have seen more trouble than most. And Roerich was often at the center of the maelstroms that have tortured Russia. Also, he never chose the smooth path and seemed even to seek out life's obstacles as if he found nourishment in them.

He was an indefatigable climber: he climbed mountains, and he also climbed life. Another saying that he liked to repeat, also related to obstacles, was, "It is easier to climb a rocky slope than a smooth one. The rocks provide steps on which one can find the force to move upward. And so it is in life." This book is about a life that was precisely devoted to climbing, to finding the rocks on which to gain a foothold, and to exploration and creative activity.

Roerich ranged through Central Asia with the full force of the curious and subjected it to the eye of the scientist, the adventurer, the artist, and the spiritual seeker. Everything was there to be explored, to be dug up, to be recorded on paper and

canvas. For him, Central Asia was the repository of the wisdom of the ages, the heart of the planet, the place to which one returns and from which one emerges reborn.

Roerich devoted himself to the search for the seed of Good on Earth. He wanted to learn how this seed can be made to flourish, how it can be used to solve humanity's vast array of problems in order to reach the goal of peace and planetary harmony. This search took him to many parts of the world, but Central Asia—the Heart of Asia—was for him the true source, the field in which this seed of Good could be found. Shambhala was a reality to Roerich, an unquestioned fact, the heart of the planet, the place to which we owe our existence, our spiritual survival, and our knowledge. The search for Shambhala is the search for the solution to the problems of existence, for the vanquishing of obstacles, and for the discovery of the great freedom that lies beyond difficulty, tragedy, and destruction.

Of course, *Heart of Asia* can be read as metaphor. Few of us can climb these high passes or search for the great Shambhala, except in our hearts. And therein lies the value of such a book. It is not just a guidebook to the countries traversed. It is a guidebook for our hearts, one in which we can explore just as Roerich did and find everything that he found: the obstacles, troubles, and tragedies, yes, but also the victory and the liberation.

Daniel Entin, Director
Nicholas Roerich Museum
October 1990

HEART OF
Asia

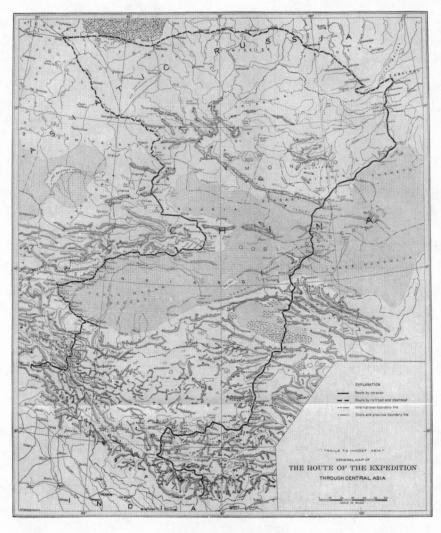

Map illustrating Roerich's route through Central Asia,
courtesy of the Nicholas Roerich Museum.

PART I

THE HEART OF ASIA

Is the heart of Asia beating? Or is it suffocated by the sands?

From the Brahmaputra to the Irtysh, from the Yellow River to the Caspian Sea, from Mukden to Arabia—everywhere are terrible, merciless waves of sand. The cruel Taklamakan is a threatening apotheosis of lifelessness, deadening the central part of Asia. The old Imperial Chinese road is hidden beneath moving sands. Out of sandy hills, trunks of a once mighty forest lift their seared arms. Like deformed skeletons, the age-devoured walls of ancient cities stretch along the road.

Perhaps near this very spot passed the great travelers, the migrating nations. The eye, here and there, glimpses isolated kereksurs, menhirs, cromlechs, and rows of stones, silent guardians of ancient cults.

The extremities of Asia, to be sure, wage a gigantic struggle with the ocean tides. But is Asia's heart alive? When Hindu yogis arrest their pulses, their hearts still continue their inner functions. So, too, the heart of Asia. In oases, in yurtas, in caravans, distinctive thought lives on. The masses of people, entirely isolated from the outside world, who receive some distorted message of outside events only after a lapse of months, do not die. Each sign of civilization, as we shall see, is greeted by them as a benevolent, long-awaited message. Rather than reject possibilities, they try to adapt their religions to the new conditions of life. This is apparent when we see what the

1

people in the most remote deserts say of the leaders of civilization and humanitarianism.

The name of Ford, for instance, has penetrated into the most remote yurtas and provinces.

Amidst the sands of the Taklamakan, a long-bearded Moslem asks, "Tell me, could a Ford negotiate the old Chinese road?"

And near Kashgar they ask, "Can a Ford tractor plow our fields?"

In Chinese Urumchi, on the Kalmuk steppes, throughout Mongolia, the word "Ford" is used as a synonym for mechanical power.

A grey-bearded Old Believer in the wild Altai mountains, and also a youth of the cooperative, say enviously, "In America, you have a Ford. But, unfortunately we have none." Or, "If only Ford were here."

Even in the Tibetan highlands, they dream of carrying a Ford, in parts, up through the mountain passes.

Crossing powerful streams, they ask, "But could your Ford cross this?"

Ascending steep slopes, they ask again, "And could a Ford also climb up here?"—as if they were speaking of some mythical giant who can surmount all obstacles.

And another American name has penetrated into the most secluded spots: In a far-away corner of the Altai, in a peasant's hut, in the most venerated corner where the sacred images are kept, one may recognize a familiar face—a yellowish portrait apparently taken from some stray magazine. Looking closer, you see that it is none other than President Hoover himself.

The Old Believer says: "This is he who feeds the people. Yes, there exist such rare, remarkable persons who not only

feed their own nation, but other peoples also. Yet the mouth of the people is not a small one."

The old man himself had never received an American food package, but the living legend has crossed rivers and mountains proclaiming how the generous giant kindheartedly distributed food and nourished the nations of the world.

One would never expect that news from the outside world could penetrate to the outskirts of Mongolia. But in a forsaken yurta a Mongol again tells you that somewhere beyond the ocean there lives a great man who feeds all starving people. And he pronounces a name in a rather strange way, sounding somewhat like Hoover or Koovera—the Buddhist deity of wealth and good fortune. In the most unexpected places, a traveler who has mastered the local language can encounter inspiring legends about the great people working for the good of all.

Through the Rockefeller institutions, the name of Rockefeller has also reached even far-off cities. With pride and satisfaction, the people speak of their collaboration with these institutions and the way they have been helped by them. The generosity of this American hand has created a direct, widespread feeling of gratitude and friendship.

The fourth outstanding cultural name, widely known in the vastness of Asia, is that of Senator Borah.* A letter from him is regarded as a good passport everywhere. Sometimes in Mongolia, or in the Altai, or in Chinese Turkestan, you may hear a strange pronunciation of this name: "Boria is a powerful man!"

In this way, popular wisdom evaluates the great leaders of

*American politician: William Edgar Borah (1865–1940).

our times. This is so valuable to hear. So precious is it to know that human evolution, in unexplainable ways, penetrates the future.

The American flag accompanied us everywhere, fastened to a Mongolian spear. It accompanied us through Sinkiang, through the Mongolian Gobi, through Tsaidam, and through Tibet. It was our standard during the encounter with the wild Panagis. It greeted the Tibetan governors, princes, and their generals. Many friends did it meet and few enemies. And even these few enemies were of quite a special kind: the governor of the northern Tibetan fortress Nagchu, for example, who assured us that there were only seven nations in all the world; another was Ma, the Tao-tai of Khotan, a complete ignoramus, but notorious for his murders.

But the friends were numerous. If only the West could see with what intense interest all photographs of New York skyscrapers were examined and how hungrily the people listened to our narratives of life in America, Westerners would rejoice in the knowledge that such masses of simple people are attracted to cultural achievements. *is that it?*

Of course, in a brief survey we cannot describe in detail the whole of central Asia. But even in piecemeal fashion, we can still review the contemporary state of those vast lands and glance at the monuments of a heroic past as well as the untold riches of Asia.

Here, as everywhere, you can see remarkable monuments of refined thought based on the ancient wisdom and the cordiality of human relationships. You can rejoice at beauty and be easily understood. But do not be astonished to find, in the very same places, perverted forms of religion, ignorance, signs of decay and degeneration.

We must take things as they are. Without conventional

sentimentality, we must greet the light and justly expose pernicious darkness. We must carefully discriminate between prejudice and superstition and the hidden symbols of ancient knowledge, greeting all who aspire toward creation and construction and deploring the barbaric destruction of the treasures of nature and of the spirit.

Of course, as an artist my main aspiration in Asia was toward artistic work, and it is difficult to say how soon I shall record all my artistic impressions and paint from my sketches—so generous are these gifts of Asia. No knowledge acquired in books or in museums enables one to express Asia or any other place without having seen it with one's own eyes and having made at least some notes and sketches at the sites themselves. The magic and intangible ability of art to persuade comes only by the continuous accumulation of real impressions. It is true, mountains everywhere are mountains, water everywhere is water, sky everywhere is sky, and men everywhere are men. Nevertheless, if seated before the Alps you were to attempt to picture the Himalayas, something inexplicable and convincing would be lacking.

In addition to its artistic aims, our expedition planned to study the location of the ancient monuments of central Asia, to observe the present condition of religions and creeds and to note the traces of the great migrations of nations. This latter problem has always been of special interest to me. In the latest discoveries of the Koslov expedition, in the works of Professors Rostovtsev, Borovka, Makarenko, Toll, and many others, we see a great interest in Scythian, Mongolian, and Gothic antiquities. The ancient discoveries in Siberia, the traces of the great migrations in Minusinsk, the Altai, and the Urals, add extraordinarily rich artistic and historic material to the study of European Romanesque and early Gothic and how close

these themes are to contemporary artistic creations. Many of these animal and floral stylizations might have come from the best modern workshop.

❖ ❖ ❖

The main route of the expedition encircled central Asia:

Darjeeling, the monasteries of Sikkim, Benares, Sarnath, Northern Punjab, Rawalpindi, Kashmir, Ladakh, Karakorum, Khotan, Yarkend, Kashgar, Aksu, Kuchar, Karashahr, Toksun, the Turfan region, Urumchi, T'ien-Shan, Kozeun, Zaisan, Irtysh, Novosibirsk, Biisk, the Altai, Oirotia, Verkhneudinsk, Buryatia, Troitskosavsk, Altyn-Bulak, Ulan-Bator, Yum-Beise, Anhsi-chou, Shih-pao-ch'eng, Nanshan, Sharagolji, Tsaidam, Neiji, the Marco Polo range, Kokushili, Dungbure, Nagchu, Shentsa-Dzong, Tingri-Dzong, Shekar-Dzong, Kampa-Dzong, Sepo La, Gangtok, and back to Darjeeling.

We crossed the following mountain passes, of which there are thirty-five, from fourteen thousand to twenty-one thousand feet:

Zoji La, Khardong La, Karaul Davan, Sasser Pass, Dabzang Pass, Karakorum Pass, Suget Pass, Sanju Pass, Urtu-Kashkariym Daban, Ulan Daban, Chakharin Daban, Khentu Pass, Neiji La, Kokushili Pass, Dungbure Pass, Thang La, Kam-rong La, Ta-sang La, Lamsi Pass, Naptra La, Tamaker Pass, Shentsa Pass, Laptse-Nagri, Tsang La, Lam-Ling Pass, Pong-chen La, Dong-chen La, Sang-mo La, Kyegong La, Tsug-chung La, Gya La, Urang La, Sharu La, Gulung La, and Sepo La.

While speaking of the crossing of these passes, it may be mentioned that, except on the Thang La, during the entire journey no one suffered seriously. In the case of the Thang La,

conditions were exceptional. There was a feeling of nervousness in the expedition over the uncertain negotiations with the Tibetans. The conditions of the pass itself are also most exacting. My son George had such an exhausting heart attack there that he almost fell from his horse. Our doctor administered large doses of digitalis and ammonia and, expressing anxiety for George's life, restored his blood circulation by massage. Lama Malonov also fell from his horse there and was found lying unconscious on the ground. In addition, three more members of the caravan had serious attacks of "soor," or mountain sickness, with symptoms of headache, poor blood circulation, nausea, and general fatigue. In any case, such weakness, to a greater or lesser extent, is characteristic during the crossing of mountain passes. On the passes, bleeding often sets in, first from the nose and later from other unprotected organs.

The same symptoms can also be seen in animals at altitudes above fifteen thousand feet. The caravan road, especially through Khardong, Sasser, and Karakorum, is covered with skeletons of all sorts of animals: horses, donkeys, mules, yaks, camels, and dogs. On the way we saw several weak animals that had been left behind. Bleeding heavily, motionless and trembling, they awaited their end. Their death could not be averted. There would have been only one way to save them: to take them down from this altitude of seventeen or eighteen thousand feet to seven or eight thousand feet; this was impossible. In our caravan, we had cases of bleeding among the men and animals but, fortunately, without any disastrous results. Probably the measures that we took each time before crossing a pass prevented this.

Inexperienced travelers might think that before climbing difficult heights it would be advisable to fortify themselves

with meat and brandy and by smoking. But these three are the greatest enemies. Our experienced Ladakhi guides warned us that in crossing the passes, hunger was most beneficial to men and animals and that nothing stimulating should be taken. At each pass, we always started out before dawn, drinking but a small cup of hot tea. Nor were the horses given any food. The lama who was with us bled several times, but the septuagenarian Chinese interpreter never had any trouble when crossing passes. Of course, every superfluous movement or any increased work caused weakness, giddiness and, with some people, even nausea, but a few minutes' rest restored the circulation of the blood.

We also suffered from so-called mountain blindness. Three of us had it in varying degrees—the Kalmuk Khedub, the Tibetan Konchok, and myself. This unpleasant trouble lasted five or six days. In my case, the right eye was affected; and, after two days, I saw everything double but quite clearly and distinctly. Khedub and Konchok saw everything fourfold. We verified this carefully and repeatedly obtained the same results.

Equally unpleasant, especially for Mrs. Roerich, was the so-called hot snow—when the snow, reflecting the sun's rays, emits an intolerable heat from which it is impossible to find escape.

We had three other unfortunate occurrences in the caravan: attacks of heart failure that carried away three people; inflammation of the lungs, of which two more died; and several people in our caravan suffered from scurvy, among them one European, the chief of our transport. It must be mentioned that in northern Tibet we met with many, most severe cases of scurvy among the local population.

In addition to the main force of the expedition, consisting

of Mrs. Roerich, my son George, and myself, plus the caravaneers and servants, we had several collaborators from time to time during our long travels. During our Sikkim journey, we were accompanied by my second son, Sviatoslav, and Lama Lobzang Mingyur Dorje, the well-known scholar of Tibetan literature and teacher of most of the European Tibetologists. Every traveler through Sikkim is cordially received by the general of the Tibetan army, Laden-La, now in the British service, who assists travelers in every way. As we traveled further, Tsai Han-chen, a Chinese interpreter and the septuagenarian officer of the Chinese Army, and Lobzang, a Kalmuk lama, went with us. In the Altai mountains we met Sina and Maurice Lichtmann. After Ulan-Bator, the expedition was joined by Dr. Riabinin; Porten, the chief of our transport; and two sisters, Ludmila and Raya Bogdanova, who were helpers of Mrs. Roerich. The sisters were local Cossack girls and Raya, the younger of the two, was only thirteen when they joined the expedition. I believe she was the youngest non-Tibetan ever to cross the severe uplands of Tibet. The presence of three women who shared all the dangers of the terrible frost and all the hardships along the way, must be definitely stressed. In Sharagolji, before Ulan Daban, two members were added: Colonel K. and G., in charge of expedition supplies.

Let us begin with Sikkim:

This blessed country, full of reminders of the illumined leaders of religions, leaves an impression of great calmness. Here lived Padma Sambhava, the founder of the Red Hat sect; and Atisha, who proclaimed the teaching of Kalachakra, crossed this country on his way to Tibet. Here in the caves dwelt many ascetics filling space with powerful thoughts of blessing.

Hermits still live behind Kanchenjunga in subterranean caves; and only a trembling hand, stretched out for food in answer to a prearranged knock, indicates that the physical body is still alive. All seventeen peaks of the Himalayas shine above Sikkim. From west to east they are Kang Peak, Jannu, Little Khabru, Khabru, Dom Peak, Talung Peak, Talung saddle, Kanchenjunga, Pandim, Jubonu, Simvoo, Narsing, Siniolchu, Pakichu, Chomiomo, Lama Andem, Kanchenjhau.

It is a realm of snows, its outlines changing with every variation of light! It is truly inexhaustible in impressions and ceaselessly evocative.

Nowhere else on earth are two such entirely different worlds expressed. Here is the earthly world with its rich vegetation, brilliant butterflies, pheasants, leopards, panthers, monkeys, snakes, and innumerable other animals which inhabit the evergreen jungles of Sikkim. And above the clouds, in unexpected heights, shines the snowy kingdom which has nothing in common with the busy anthill of the jungles. It is an eternally moving ocean of clouds with untold varieties of mist.

Kanchenjunga has attracted the attention equally of Tibetans and Indians. Here was created the inspiring myth about Shiva, who drank the poison of the world for the sake of humanity. Here, from the churning of the clouds rose the brilliant Lakshmi for the joy of the world.

In general, a beneficent atmosphere is maintained in the monasteries of Sikkim. On every hill, on every summit, as far as the eye can reach, you see white specks—these are all strongholds of the teaching of Padma Sambhava, the official religion of Sikkim. The Maharajah of Sikkim, who lives in Gangtok, is deeply religious. The Maharani, his wife, is of Tibetan descent, and her education is quite exceptional compared to that of the majority of Tibetans.

All the monasteries of Sikkim are associated with relics and ancient traditions. Here lived Padma Sambhava himself. Here the Teacher meditated upon a rock. When this rock splits anew, it will mean that the life of this place has been diverted from the path of righteousness.

The Pemayangtse monastery is the official center of religion in Sikkim. Near this monastery there are still ruins of the ancient palace of former Maharajahs. But of far greater spiritual importance is the old monastery of Tashi-ding, which is one day's march from Pemayangtse. Every traveler should visit this remarkable place despite the difficult path of a bamboo bridge over a wild torrent.

We were in Tashi-ding in February, at the time of the Tibetan New Year, when thousands of visitors from the neighboring villages lend an exceptional picturesqueness to the ancient place. At that season in Tashi-ding, the annual miracle of the Chalice is also performed. Every year an ancient stone chalice is half filled with water and sealed in the presence of the lamas and representatives of the Maharajah. The following year, also on New Year's Day, the casket where the chalice is kept is unsealed. The ancient silk cloth in which the chalice is wrapped is removed and, according to the amount of water in the chalice, the future is predicted. The water has either decreased or, as is told, sometimes increased. It is said to have increased considerably in 1914 before the Great War. Such an increase always means calamity and war.

In all the monasteries of Sikkim you can feel a friendly attitude toward foreigners, and the hospitable atmosphere is undisturbed. The head lamas readily show you their treasures, among which are many old objects of fine workmanship.

We were in Sikkim at the time of the third ill-fated Everest Expedition; and the lamas told us, "We wonder why the

pelings—foreigners—take such trouble in climbing. They will not be successful. Many of our lamas have been on the top of Mount Everest, but they were there in their astral bodies."

In these places, many things that might seem strange to Europeans sound quite natural. Recently in Darjeeling, a strange episode took place involving an old lama: During an incident in the street, an old lama, a casual spectator, was arrested by the police together with the guilty agitators. The lama did not protest and, with all the others, was sentenced to a certain term of imprisonment. When the term was over and the lama was to be released, he asked permission to remain in prison because it was quiet there and most suitable for concentration!

From Sikkim we also carried with us wonderful, beneficent legends. In the temple, for instance, while the gigantic trumpets roared, the lama asked us, "Do you know why the trumpets of our temples have so resonant a tone?"

Then he explained, "The ruler of Tibet decided to summon from India, from a place where dwelt the Blessed One, a learned lama, in order to purify the fundamentals of the teaching. How to meet the guest? The High Lama of Tibet, inspired by a vision, designed a new trumpet so that the guest should be received with unprecedented sound. The meeting was a wonderful one—not by the wealth of gold but by the grandeur of sound! . . ."

"And do you know why the gongs in the temple ring out with such great volume? The silver-toned gongs and bells resound at dawn and evening when the higher currents are intensified. Their sound reminds one of the beautiful legend of the Chinese emperor and the great Lama. In order to test the knowledge and clairvoyance of the Lama, the emperor made a seat for him of sacred books and, covering them with fabrics,

invited the guest to sit down. The Lama said certain prayers and then sat down.

"The emperor demanded of him, 'If your knowledge is so universal, how could you sit down on the sacred books?'

" 'There are no sacred volumes,' answered the Lama. And the astonished emperor found, instead of his sacred volumes, only blank paper.

"The emperor thereupon gave to the Lama many gifts and bells of liquid chime. But the Lama ordered them to be thrown into the river, saying, 'I will not be able to carry these. If they are necessary to me, the river will carry them to my monastery.'

"And indeed the waters carried the bells to him, with their crystal chimes, clear as the waters of the river."

About talismans, the Lama also explained, "Talismans are regarded as sacred. A mother many times asked her son to bring her a sacred relic of the Buddha. But the youth kept forgetting her request. She said, 'I will die because of you if you do not bring a relic to me.' But the son set off to visit Lhasa and again forgot his mother's wish. A half-day's journey from his house, he recalled his mother's request. But where can one find sacred objects in the desert? There are none. But the traveler came upon the skull of a dog. He decided to take out a tooth and, folding it in yellow silk, he brought it to the house.

"The old woman asked of him, 'Have you again forgotten my last request, my son?' He then gave her the dog's tooth wrapped in silk, saying, 'This is the tooth of the Buddha.'

"And the mother put the tooth into her shrine, and performed before it the most sacred rites, directing all her worship to her holy-of-holies. And the miracle was accomplished. The tooth began to glow with a pure ray, and many miracles and sacred objects were manifested by it."

I cannot refrain from mentioning here incidents that occur in these places proving the power of the will. During the visit of the Tashi Lama to India, he was asked whether it was true that he had some special psychic powers. The spiritual leader of Tibet smiled but did not reply. But within a few minutes he disappeared. All present began to search for him, but in vain. Then a newcomer entered the garden where this occurred and was surprised at the unusual sight: The Tashi Lama was sitting quietly under a tree, surrounded by people anxiously searching for him—in vain!

Another case of willpower: In a train of the Bengal railway a sadhu was found without a ticket. He was put off the train at the next station. The sadhu sat on the platform not far from the engine and remained motionless. The signal was given for the train to leave, but the train did not move. The passengers, already displeased at the treatment accorded the sadhu, paid special attention to this fact. The signal was given again—and again the train did not move. Then the passengers demanded that the sadhu be invited back. The holy man was solemnly reinstated in his seat, and then the train continued safely on its way.

I will not pause to speak of Benares or its pundits or the sacred ceremonies on the Ganges. We were surprised that a great part of Sarnath, the memorial site where Buddha began his sermons, is still unexplored beneath the earth. Even those ruins, which one may now see, have been excavated only recently. A strange fate follows most of the places connected with the personal activity of the great founder of Buddhism. Kapilavastu and Kushinagara, the places of birth and death of the Lord

Buddha, are in ruins; Sarnath is not yet completely excavated. There is some special significance in this. Until recently, several scientists have tried to prove that Gautama Buddha never existed.

In spite of the facts in the voluminous Buddhist literature, in spite of the inscriptions on the ancient columns of King Ashoka, the French scientist Senart has tried to prove in his book that the Buddha never existed and was nothing more than a solar myth. But here, also, our exact knowledge has provided evidence of the human existence of Gautama Buddha. For soon after, there was excavated in Piprava, in Nepalese Terrai, an urn that was dated with an inscription and contained the ashes and bones of Lord Buddha. A similar historical casket with part of the relics of the Teacher, buried by King Kanishka, was found near Peshawar and also testifies definitely to the existence of the Great Teacher. It is curious to note that the last discovery was made in accordance with chronicles of old Chinese pilgrims noted for the accuracy of their narratives. We had occasion to prove this for ourselves more than once.

The Northern Punjab, Harapa, for instance, north of Lahore, provides much historic material concerning the most ancient epoch of India, and also concerning Buddhism and seventh-century India. Buddhism is not forgotten here. Gautama Rishi, as the local Punjabi and Pahari name the Lord Buddha, is greatly venerated. The ruins of ancient Buddhist temples, with typical Buddhist images, indicate that here on the ancient road from Tibet, Buddhism flourished for ages. In the Kuluta (or Kulu) Valley alone, 363 Rishis are worshipped. This whole

region is connected with the greatest names. It is said that Arjuna laid a subterranean passage from Kulu to Manikaran. Here also, in Mandi State, is the famous Ravalsar Lake, connected with the name of Padma Sambhava. Even now, many lamas descend into the valley from Tibet over the Shipki and Rothang passes to worship the memory of the Teacher. The places are filled with reminiscences, for Mandi and Kulu form the miraculous land, Zahor, to which such tribute is paid in Tibetan literature. The experienced scientist, Dr. A.H. Franke, in his book *Antiquities of Ancient Tibet*, page 123, quotes the following:

> Let me now add a few words about Mandi, collected from Tibetan historical works. There can exist no reasonable doubt as regards the identification of the Tibetan Zahor with Mandi; for on our visit to Ravalsar we met with numerous Tibetan pilgrims, who said that they were traveling to Zahor, thereby indicating the Mandi State, if not the town. In the biography of Padma Sambhava, and in other books referring to his time, Zahor is frequently mentioned as a place where this teacher (750 A.D.) resided. The famous Buddhist teacher Santa Rakshita, who went to Tibet, was born in Zahor. Again in the days of Ral-pa-chan (800 A.D.) we find the statement that during the reigns of his ancestors many religious books had been brought to Tibet from India, Li, Zahor, and Kashmir. Zahor was then apparently a seat of Buddhist learning, and it is even stated that under the same king, Zahor was conquered by the Tibetans. But under his successor, the apostate King Langdarma, many religious books were brought to Zahor, among other places, to save them from destruction.
>
> Among the Tibetans there still prevails a tradition regarding the existence of hidden books in Mandi, and this tradition in all probability refers to the above-mentioned books. Mr.

Howell, Assistant Commissioner of Kulu, told me that the present Thakur of Kulong, Lahul, had once been told by a high lama from Nepal where the books are still hidden.

You see what remarkable traditions are connected with Kulu and Mandi, the ancient Kuluta and Zahor. The scientific world still hopes, as yet in vain, to find the most ancient copies of Buddhist books.

Not only Buddhist antiquities, not only the name of Arjuna, are connected with Kulu Valley, but even the Manu—the First Lawgiver himself—gave his name to the village of Manali.

In Kulu Valley resided Vyasa, the famous compiler of the Mahabharata. Here is Vyasakund, the sacred place of the fulfilment of all wishes.

On the border of Lahul, in the rocks, there are two carved images of a man and a woman about nine feet high. The same legend is told about them as about the gigantic images of Bamian in Afghanistan: That their height corresponds to that of the original inhabitants of this place.

In the same way, Kashmir is full of antiquities. Here are Martand and Avantipur, connected with the flowering of activity under King Avantisvamin. Here are many ruins of temples and cities of the sixth, seventh, and eighth centuries, in which the architectural detail surprises one by its similarity to the early Romanesque. Of Buddhist times, almost nothing has survived in Kashmir, although great figures of the old Buddhism lived here, such as Nagarjuna, Asvaghosha, Rakshita, and many others, who afterwards suffered during the change from Buddhism to Hinduism. Here is the "Throne of Solomon" and on the same summit, the foundation of the temple laid by the son of King Ashoka. I will not speak of Srinagar itself. True, in the rough stonework of the river embankments and

the foundations of the buildings, one can trace singular stones with beautiful carvings dating from the greatest period. But these are fragments which have nothing in common with the present sad position of the city.

In Srinagar, we first encountered the curious legend about Christ's visit to this place. Afterwards, we saw how widely spread in India, in Ladakh, and in central Asia was the legend of the visit of Christ to these parts during the long absence mentioned in the Gospels. The Moslems of Srinagar told us that the crucified Christ—or, as they call Him, Issa—did not die on the cross, but only lost consciousness. The disciples took away His body, secreted it and cured Him. Later, Issa was taken to Srinagar where He taught the people. And there He died. The tomb of the Teacher is in the basement of a private house. It is said that an inscription there states that the son of Joseph was buried in that house. Near the tomb, miraculous cures are said to take place and fragrant aromas fill the air. In this way, the people of other religions desire to have Christ among them.

The ancient caravan road from Srinagar to Leh is covered in a seventeen days' march. But one is usually advised to take a few days more. Only cases of extreme need can induce the traveler to make this journey without interruption. Such unforgettable places as Maulbek, Lamayuru, Basgu, Khabru, Saspul, Spithug, stop one instantly and imprint themselves forever in memory, both from an artistic and a historical point of view.

Maulbek—now a declining monastery, to judge by the ruins—must have once been a real stronghold, boldly occupy-

ing the summit of a huge rock. Near Maulbek, on the main road, you are startled by an ancient gigantic image of Maitreya. You feel that not a Tibetan hand, but probably a Hindu, carved this image at the time of Buddhist glory.

In his chronicles, Fa-hsien, the Chinese traveler, mentions a huge image of Maitreya here. We wonder whether he refers to this relief. When we were approaching Khotan, we heard, quite by chance, that on the back of this rock is an ancient Chinese inscription. In this place we might have expected a Sanskrit, Tibetan, or even a Mongolian inscription, but Chinese is quite a surprise. Let the next explorer study the back of the rock of Maitreya. Further on the way, you become accustomed to these gigantic monuments and structures which, like eagles, hold these high waterless summits in their grip. But the first impression, as usual, is the most striking.

One must have a sense of beauty and of fearless self-denial to build strongholds on such heights. In many such castles, long subterranean passages leading to a river were hewn in the rocks so that a loaded donkey could just manage to pass along. This fairy tale of subterranean passages, as we shall see, has created many of the best sagas. As in Sikkim, the Ladakhi lamas turned out to be kind, tolerant of other faiths, and hospitable to travelers, as Buddhists should be.

All three of the main teachings of Lamaism can be found in Ladakh: Gelugpa, the yellow faith proclaimed by Tsong-Kha-Pa; the Red Hat sect, followers of Padma Sambhava; and even the oldest, Bonpo, the so-called Black Faith of pre-Buddhist origin. These last, worshippers of the gods of Svastika, still remain for us an inexplicable enigma. On one hand, they are sorcerers, Shamans, perverters of Buddhism. But, on the other hand, in their teaching can be found faint traces of Druidic fire and nature worship. The literature of Bonpo has not yet

been translated and has not been interpreted, but there is no doubt it deserves thorough research.

With even more interest we approached Lamayuru. This monastery is considered a stronghold of Bonpo. Of course, the Bonpo of Lamayuru is not a true Bonpo. It is considerably mixed with Lamaism and Buddhism. In the monastery there is an image of Buddha and also one of Maitreya. This is, of course, quite incompatible with the basic principles of the Black Faith. But the monastery itself, and its situation, are quite unique in their spellbinding beauty. We thought to ourselves that if we encountered such beautiful sights in Ladakh, then what could we not expect in Tibet!

An equally romantic impression of majesty is conveyed by Basgu, where the present-day temples are intermingled with ancient ruins. These ruins are attributed to Zorawar and other Kashmir conquerors who invaded Ladakh, mercilessly destroying Buddhist monasteries. All these half-ruined towers and endlessly long walls crowning the rocky peaks speak of the ancient glory of Ladakh and of the valiant spirit of its founders. The name of the great hero of Asia—Gesar Khan— rings over these places.

In Kalatse, near the old fort, on a shaky bridge across the yellow thundering Indus, you hear the story of how the hand of Sukamir, the Kashmir invader defeated by the Ladakhi, was nailed to the bridge as a sign of warning. "But," adds the storyteller, "a cat ate the enemy's hand, and in order to keep up the moral lesson, the hand of a dead lama had to be nailed to the bridge." Such is the play of fate.

In Saspul we again find a remarkable temple with extremely ancient images of Maitreya. The literature of Ladakh is extensive. But one feels that still more may be discovered here, restoring the lost milestones of many an ancient path.

BASKUL?

On the rocks, halfway to Kashmir, some ancient carvings may be seen. They are regarded as Dard images and are ascribed to the ancient inhabitants of Dardistan. On more closely studying these typical carvings on the surfaces of the rocks, one may distinguish two different types. One is new, drier in its technique. In this type of carving one may see suggestions of Buddhist objects, stylizations of suburgans and so-called lucky signs of Buddhism. But nearby, sometimes on the same rocks, one may see a rich, soft technique, reminding one of the neolithic. In these ancient images one may distinguish ibexes with huge, powerfully curved horns, yaks, hunters, archers, round dances, and ritual ceremonies. The character of these carvings merits careful attention because we saw similar designs on the rocks near the oasis Sanju in Sinkiang, in Siberia, in the Trans-Himalayas, and in the Halristningar of Scandinavia. Let us not hurry with conclusions, but first study and compare.

In Nimu, a small village before Leh, at eleven thousand feet, we had an experience that can, under no circumstances, be overlooked. It would be most interesting to hear of analogous cases. It was after a clear, calm day. We camped in tents. At about 10 P.M., when I was already asleep, Mrs. Roerich approached her bed to remove the woolen rug. But hardly had she touched the wool when a big rose-violet flame of the color of an intense electric discharge shot up, forming what seemed like a whole bonfire about a foot high. A shout from Mrs. Roerich— "Fire, fire!"—awoke me. Jumping up, I saw the dark silhouette of Mrs. Roerich and behind her a moving flame clearly illuminating the tent. Mrs. Roerich tried to extinguish the flame with her hands, but the fire flashed through her fingers, escaped her hands, and burst into several smaller fires. On touching the flames, one felt a slightly warming effect, but there was no

burning, sound, or odor. Gradually the flames diminished and finally disappeared, leaving no traces whatsoever on the bed cover. We had occasion to study many electric phenomena, but I must say that we never experienced one of such proportions.

In Darjeeling, a ball of lightning passed only two feet from my head. In Gulmarg, in Kashmir, during an uninterrupted thunderstorm of three days, when hail fell as big as pigeons' eggs, we studied many kinds of lightning. In the Trans-Himalayas, we repeatedly experienced the effect upon ourselves of different electrical phenomena. I remember how in Chunargen, at an altitude of fifteen thousand feet, I awoke one night in my tent, and touching my bedrug, was surprised at the blue light flashing from my fingertips as though enwrapping my hand. Believing that this could occur only in contact with woolen material, I touched the linen pillowcase. The effect was again the same. Then I touched all kinds of objects— wood, paper, canvas; in each case the blue light flashed up, intangible, soundless, and odorless.

The entire Himalayan region offers exceptional fields for scientific research. Nowhere else in the whole world can such varied conditions be concentrated: Peaks up to almost thirty thousand feet; lakes at an elevation of fifteen thousand feet; deep valleys with geysers and all types of hot and cold mineral springs; the most unsuspected vegetation—all this vouches for unprecedented results in new scientific discoveries. If one could compare scientifically the conditions of the Himalayas with those of the uplands in other parts of the world, what remarkable similarities and differences would arise! The Himalayas are a veritable Mecca for a sincere scientist. When we recalled the book of Professor Millikan, *The Cosmic Ray*, we imagined the wonderful possibilities that this great scientist would find on these Himalayan heights. May these dreams come true, in the name of true science!

The city of Leh, the residence of the former Maharajah of Ladakh, now conquered by Kashmir, is a typical Tibetan town, with clay walls, temples, and long rows of suburgans that lend a solemn silence to the place. This city, on a high mountain, is crowned by the eight-story palace of the Maharajah. At the latter's invitation we stopped there, choosing for our dwelling the top floor of the stronghold that trembled under the violent gusts of wind. During our occupancy a door and part of the wall collapsed. But the wonderful view from the roof made us forget the instability of the castle.

Below the palace lies the whole city: Bazaars crowded with noisy caravans, orchards and, around the city, great fields of barley from which garlands of merry songs resound at the close of the day's work. The Ladakhi women walk about in their picturesquely high fur caps with turned-up earpieces. Down their backs hang long bands decorated with a great amount of turquoise and small metal ornaments. Across their shoulders, like an ancient Byzantine korsno, they generally wear the skin of a yak, fastened on the right shoulder with a fibula. Among the richer women, this korsno is of colored cloth so that they resemble, even more, the real Byzantine icons. And the fibulae on their right shoulders might have been excavated in Nordic and Scandinavian tumuli.

Not far from Leh, on a stony hill, are ancient graves believed to be prehistoric and reminiscent of Druidic antiquities. Also nearby is the site of the old Mongolian camp from which the Mongols tried to conquer Ladakh. In this valley, too, are Nestorian crosses that remind us once more how widespread were Nestorianism and Manicheism in Asia.

In Leh, we again encountered the legend of Christ's visit to these parts. The Hindu postmaster of Leh and several Ladakhi Buddhists told us that in Leh, not far from the bazaar, there still exists a pond, near which stood an old tree. Under this tree,

before his departure to Palestine, Christ preached to the people. We also heard another legend of how Christ, when young, arrived in India with a merchant's caravan and how He continued to study the higher wisdom in the Himalayas. We heard several versions of this legend which has spread widely throughout Ladakh, Sinkiang, and Mongolia; but all versions agree on one point: That during the time of His absence, Christ was in India and Asia. It does not matter how and from where the legend originated. Perhaps it is of Nestorian origin. It is valuable to see that the legend is told with complete sincerity.

The entire atmosphere at Ladakh seemed to be under benevolent signs for us.

We gathered our caravan to cross the Khotan over the Karakorum Pass without much difficulty. Two roads were possible, one over seven passes, and the other along the River Shayok, with fewer passes but with a long stretch in water. The men of the caravan chose the first route via the mountain passes, preferring not to wade through the fairly deep Shayok in September and risk catching cold.

So we left Leh on 19 September 1925. And it was high time, for the monsoon of Kashmir, turning into snowy clouds, drove us northward.

As we left the town, the local women met us on the road carrying consecrated yak's milk with which they anointed the foreheads of people and animals, wishing us a happy journey. And they had cause, for the mountain passes can be most severe. Afterwards, in Khotan, we saw people who had been carried down from the passes with their limbs frozen black,

and we heard how a year earlier, near Khardong, a whole caravan, with about a hundred horses, was found frozen. Men were found standing up, seemingly alive, some of them with their hands to their mouths, apparently uttering their last cry. And, indeed, on the heights, on frosty mornings, limbs and hands freeze very quickly. The Ladakhi now and then solicitously ran up to us offering to rub our feet and hands.

Of the seven passes of this road—Khardong, Karaul Davan, Sasser, Dabzang, Karakorum, Suget, and Sanju—Sasser turned out to be the most dangerous, especially the smooth, rounded slope of the glacier where George's horse slipped.

The last pass, Sanju, is also most unpleasant because here one has to jump over a pretty wide crevasse. One should not touch the reins but give the experienced hill yak his own way.

The Suget Pass, quite unexpectedly, afforded us an unpleasant experience. The ascent from its southern side is quite easy. But a terrible snowstorm arose and, approaching the descending slope, we saw that the narrow zigzag path was completely obstructed by snow. Near the precipice four caravans had collected, comprising about four hundred horses and mules. A party of very experienced old mules was sent down ahead without riders; and the careful animals, struggling through the deep snow, felt their way along the narrow path. Then the other caravans followed, stumbling and slipping.

Of all the seven passes, Karakorum turned out to be the easiest, although the highest. Karakorum means "Black Throne," and the pass is so called because of the black rock that crowns it.

To describe the beauty of this snowy realm, where we spent many days, is quite impossible. Such variations, such expressiveness of outline, such fantastic cities, such multi-

colored streams and torrents, and such unforgettable purple
and moon-like cliffs!

And at the same time one feels the astounding silence of
the desert! Disputes cease, all differences disappear, and all,
without exception, sense the beauty of these untrodden heights.
On the way, we encountered touching caravan traditions. Often
we saw bales of goods left behind, unguarded, by unknown
owners. Perhaps the animals fell or became too fatigued to
carry the goods that were left for another occasion. And no-
body would touch this property. Nobody would dare to trans-
gress this ethic of the caravan. We smiled, imagining what
would happen if one left property unguarded in a city street.
Yes, in the desert one enjoys greater safety.

Nobody knows exactly where the frontier is between
Ladakh and Chinese Turkestan. It is there, somewhere be-
tween Karakorum and Kurul! For in Kurul is the first Chinese
outpost. It is as if nobody owned the beautiful desert! As if it
were an unknown land! Even animals were very few there. We
also met only a few caravans. Among them were Moslem
pilgrims bound for Mecca, with their wares, to earn a green
turban and the honorable surname of "Haji."

Caravans meet on most friendly terms by night. They help
each other with their everyday needs, and, over the glowing
red campfires, ten fingers are raised in lively narrations of
unusual events. The most dissimilar and varied people meet in
this way: Ladakhi, Kashmiris, Afghans, Tibetans, Astoris,
Baltis, Dards, Mongols, Sarts, Chinese, and every one has his
own tale, nurtured in the silence of the desert.

Kurul is the first Chinese outpost on the Yarungkashdarya,
the river of black nephrite. It forms a square, enclosed by
crenelated clay walls. Inside is a dirty yard with small clay
buildings leaning against the wall of the fort. In a tiny clay hut

lives the Chinese officer. On the wall hangs a long single-barreled gun with a large single cock. This constitutes the entire arms of the officer. With him are a Kirghiz interpreter and about twenty-five men from the Kirghiz militia. The officer himself turns out to be a Chinese of good type. He examines our Chinese passport issued by the Chinese ambassador in Paris, Cheng-Lo, by order of the Chinese government. Our old Chinese thoughtfully repeats, "Chinese soil." Is he pleased or sorrowful about something?

From Kurul one may go either by a roundabout route through Kok-yar or across the last pass, Sanju, to Sanju Oasis and Khotan. We chose the more difficult but shorter way. On approaching the Sanju Pass itself, we found Buddhist caves which had never been described and which the local inhabitants called "Kirghiz dwellings." The approach to the caves was obstructed by landslides and we looked up longingly to the high, dark openings cut off from the road. Within there are perhaps frescoes and other antique works of art.

Near Sanju Oasis, the hills become smaller and finally change into a sandy desert. Anyone who has seen Egypt will understand the character of this land with its rosy reflections. On the last rock we saw a neolithic design of the same ibexes and daring archers as we had noticed in Ladakh. And in front of us was the rosy mist of Taklamakan and the welcoming das-tarkhan of the elders of the local Sarts. On the next day, beyond the Sanju Oasis, we noticed a solitary rider approaching across the desert itself. He stopped, gazed sharply around, dismounted and set something on the ground. Approaching, we saw a white cloth and on it a pumpkin and two pomegranates. A truly enchanted table: The greeting of an unknown friend.

We moved along barkhans of quicksand, often without a

trace of a road, and it was difficult to imagine that we were on the great Chinese Imperial highway, the so-called silk road, the main western artery of old China. The picturesque mazars (the burial sites of the hill Kirghiz) ended; and the mosques of the Sarts began, simple and plain as their clay houses, gathered in small oases amid the threatening sands.

When we were in the open sands, three doves came flying up to the caravan and continued flying before us as though calling us to follow. One of the local men smiled and said, "You see, the sacred bird is calling you. You must visit the old mazar guarded by the doves."

So we turned from the road and went to the old mazar and mosque, around which thousands of doves hovered, protected by the legend that he who dares to kill one of these birds perishes immediately. According to tradition, we bought grain for the birds and continued on our way.

It was 10 October, but the sun was still so hot that the stirrups burned our feet through our boots.

A day's march from Khotan, grass began to appear on the sandy barkhans, and the clay houses became more numerous. We entered the Khotan oasis, a region that Fa-hsien in 400 A.D. described as follows: "The land is rich and happy. The people prosper. They are all Buddhists. Their greatest recreation is religious music. There are several thousand priests and they belong to the Mahayana. They all receive food from the communal food stores."

Of course, present-day Khotan does not correspond in the slightest to the description of Fa-hsien. Long, dirty bazaars

and demolished clay houses do not convey the impression of wealth and prosperity. Of course, there is no evidence of Buddhism either. The few Chinese temples are very rarely open, and the Confucian gongs did not sound once during the entire four-month period of our involuntary stay there.

Among the 150,000 Sarts there are but a few hundred Chinese, and the masters of the land have become the guests. Old Khotan was about six miles away, where the village of Yotkan stands today. The old Buddhist sites have now been covered by mosques, mazars, and Moslem dwellings so that further excavations in these places are quite out of the question.

Khotan itself is at present in a transition. It has already turned away from the old. The high quality and finesse of the old workmanship have disappeared; however, contemporary civilization has not yet reached Khotan. Everything is without form, unstable, and somehow transitory. The jade carvings are coarse. The Buddhist antiques, which until recently were brought to Khotan from the surrounding area, have almost all disappeared. But to our surprise, we saw many imitations that were sometimes very accurately made and showed taste. All antiquities from Khotan should be well examined. In Khotan we also saw very well made copies of rugs in the collections of the British Museum. If these rugs are called imitations, it is quite all right; but if they follow customary procedure and pass into the hands of antique dealers, this would be very unfortunate. In its essence, Khotan still remains a rich oasis. The loess of the soil is very fertile, and the yield of grain and fruit is abundant.

Were these places to enjoy the elementary conditions for the development of culture, prosperity could be restored at once. The people are very quick, but in this large oasis with over two hundred thousand inhabitants, there is no hospital,

no doctor, no dentist. We saw people dying from the most hideous diseases without any help whatsoever. The nearest assistance, and only voluntary, is the Swedish Mission in Yarkend, an entire week's journey from Khotan.

One must say that the present rulers of China care very little, if at all, about attracting useful cultural elements to these parts.

While approaching Khotan, we heard the story of how, a year earlier, the Khotan Tao-tai Ma, acting on the orders of the governor-general of Sinkiang, Yan-Dutu, crucified and then murdered the old Titai of Kashgar. On the way, people told us, "Better not go to Khotan, the Tao-tai there is a bad man." Their warnings turned out to be prophetic.

After the first friendly official meeting, the Tao-tai and Amban of Khotan informed us that they did not recognize the passports issued by order of the Peking government and that they could not permit us to leave Khotan; they seized our arms, prohibited scientific work of any kind, and also forbade our painting. It appeared that the Tao-tai and Amban could not distinguish a plan from a painting. I will not lose time over these unpleasant incidents that proved the stupidity of the Tao-tai. I will only mention that, instead of the short stay we had intended, we were detained in Khotan for four months and only at the end of January 1926, thanks to the assistance of the British consul in Kashgar, Major Gillan, were we able to continue our journey to Yarkend, Kashgar, Kuchar, Karashahr, and Urumchi. The journey took seventy-four days.

The first part of the journey was across the snow-covered desert; but in Yarkend, at the beginning of February, the last patches of snow disappeared, and again there rose clouds of choking sand dust. But we were happy, on the other hand, to

see the first leaves of the fruit trees. The Amban of Yarkend was a man of far greater education than the Khotan authorities. He expressed his deep indignation at the absurd actions of Khotan and approved of our passports, which he said were the usual ones, which stipulated that he should assist us in every possible manner. In Yarkend, in Yangihissar, and in Kashgar, we met the friendly Swedish missionaries who supplied us with much information about the extraordinary fertility of the region and about the colossal mineral wealth that lies absolutely untouched.

Kashgar, with its triple walls and the sand cliffs along its high riverbanks, gives the impression of a typical Asiatic town. Both the Chinese Tao-tai and the British consul there welcomed us heartily. And again everything that the Khotan authorities had refused to recognize was accepted as fully valid. Even our arms were returned to us; that is, we were permitted to carry them ourselves, in a closed box, to the governor-general in Urumchi. Incidentally, during our entire journey to Urumchi, we had not one occasion to regret that our arms were sealed.

In Kashgar it was most instructive to visit what was apparently the oldest part of the city on the opposite shore of the river, where a considerable part of an old stupa may still be seen. This stupa is about as large as the great Stupa of Sarnath. Below Kashgar are several ancient Buddhist caves that have already been explored and that are connected with poetic legends. About six miles from Kashgar is the Miriam Mazar, the so-called tomb of the Holy Virgin, Mother of Christ. The legend relates that, after the persecution of Jesus in Jerusalem, Miriam fled to Kashgar where the place of her burial is marked by a mazar, worshipped even today.

From Kashgar to Aksu the road is most tedious, partly due

to the all-penetrating dust, and also to the deep quicksands and lifeless forests of gnarled desert poplars, half-burnt. It is the custom of travelers to set a tree on fire instead of building a campfire.

In Aksu, we met the first Chinese Amban to speak English. The young man dreamt of escaping from that sand-filled place as soon as possible. He showed us a Shanghai English newspaper that he had received from Mr. Cavaliere, the postmaster in Urumchi, an Italian. I was surprised that the Amban did not subscribe to a newspaper himself, but later discovered that the all-powerful Yan-Dutu had prohibited his subjects from reading newspapers. Later on, we were to see the somewhat original methods which this ruler of all Sinkiang adopted in governing his country.

The neighborhood of Kuchar is full of the ancient Buddhist cave temples which provided so many of the beautiful monuments of central Asian art. This art has received, and deserves, a high place among the monuments of ancient cultures. But, despite the attention accorded to this art, it seems to me that its value has not yet been fully recognized, especially from the point of view of artistic composition.

The site of the former cave monastery, close to Kuchar, makes an unforgettable impression. In a gorge, rows of different caves are set like an amphitheatre, all decorated with mural paintings and showing traces of many statues which have either been destroyed or removed. One may well imagine the solemnity of this place at the time when the kingdom of the Tokhars was at its height. The mural painting has survived in part.

One often has cause to resent the actions of European explorers who have removed whole parts of architectural en-

sembles to museums. One can sanction the removal of separate objects which have already lost their identity with any definite monument. But is it not unjust, from the local standpoint, to hack apart arbitrarily a composition that still stands? Would it not be a pity to cut in pieces Tuanhuang, the best preserved of the monuments of central Asia? We do not dismember Italian frescoes. Of course, there is this consideration: The majority of Buddhist monuments in Moslem lands have been, and still are, exposed to iconoclastic fanaticism. In order to destroy the images, fires are built in the caves, and as high as the hand can reach, the faces of the images are scratched with knives. We have seen traces of such destruction. The labors of such distinguished scholars as Sir Aurel Stein, Pelliot, Le Coq, and Oldenburg have safeguarded many of the monuments that otherwise would have been in the greatest danger of destruction because of the carelessness of the Chinese administration.

The old artist of central Asia, besides his knowledge of valuable iconographic details, showed a highly developed decorative feeling and a great ability to combine wealth of detail with general composition in covering large surfaces. You can well imagine how many impressions one may gather when each day one makes additional observations and when the generosity of antiquity, together with nature, provides inexhaustible artistic material.

Kuchar is a large city, entirely Moslem, and there is nothing to recall the departed kingdom of the Tokhars with its highly developed literature and education. It is said that the last Tokhar king, when threatened by his enemies, fled from Kuchar, carrying with him all his treasures. As one contemplates the endless, winding mountain ridges, one may imagine how easily these treasures might be hidden. In any case, the old treasures

of this land have gone. But the richly laden fruit trees convince one that with but slight effort, new treasures could easily be accumulated again.

On the entire journey from Kuchar to Karashahr, we were accompanied by Buddhist memories. On the left of the road there appeared, as though in faint mist, the spurs of the magnificent T'ien-Shan range, the heavenly mountains. Someone appreciated their tones of ethereal blue and named them fittingly. In these hills one already sees the permanent and nomadic monasteries of the Kalmuks. Karashahr, Olut, and Khoshut horsemen are seen instead of Sart Moslem towns.

On the way, riders approached us, already using Kalmuk saddles, and began a conversation with George and our lamas. Up till now the Kalmuks have considered themselves independent, and they relate the following tale of how they retained their independence during the time of the last Khan. They say: "The Chinese set evil charms upon the late Khan, and he transferred the sovereignty over his people to a Chinese official. This official hurried to Urumchi to report his success to Yan-Dutu. But the Kalmuk elders came to know of it and sent horsemen in pursuit of the Chinese caravan, overtaking it in the T'ien-Shan mountain passes. No one ever again heard of this caravan and no trace of it was ever discovered. The old Khan was surrounded by the elders and died soon after, and the Toin Lama became regent because the prince was not yet of age."

Of course, the Kalmuk "independence" is apparent only to themselves. Actually, they are under the thumb of Yan-Dutu and even their last cavalry detachment, formed by the Toin Lama, was removed to Urumchi while the Toin Lama himself became a voluntary or involuntary guest of Urumchi.

The Kalmuk steppes with their high grass, the golden-canopied yurtas of nomad monasteries, the purely Scythian costumes of the riders, all make one aware of a clear difference between the Sarts and Chinese of Sinkiang as opposed to the Kalmuks with their distinctive way of life.

For a time, we turned aside from the T'ien-Shan and plunged into the suffocating air of Toksun, the Turfan region. We encountered scorpions, tarantulas, subterranean canals—arycks—and unbearable heat, during which even the local people cannot walk more than two miles. Besides remarkable monuments, besides the Mother of the World, this region provided us with many legends and a tradition of travel: It is customary in Turfan to send the young people to travel under the leadership of experienced men; for the Turfans say "travel means victory over life."

In Karashahr and in Toksun, we noticed beautiful types of horses of the Karashahr breed. Whoever recalls the ancient Chinese terra-cottas of horses from the T'ang epoch should not imagine that this breed has disappeared. The Karashahr horses especially remind one of it. Most interesting are the horses with zebra-like stripes; perhaps this breed was once crossed with wild khulans.

Urumchi is the capital of Sinkiang and residence of the terrifying Yan-Dutu, who for seventeen years, despite all changes, ruled over all Chinese Turkestan with its great variety of inhabitants. The methods employed by Yan-Dutu should be remembered as one of the curiosities of history. Yan-Dutu considered himself an educated man and had a master's degree. He was constantly confronted by the contradictory interests of the Chinese, Sarts, Kirghiz, Kalmuks, and Mongols. Sometimes the ruler proclaimed himself a friend of the

Kalmuks, circulating the news that the Tashi Lama, who was in China, had been elected Emperor of China. Having won the sympathy of the Buddhists, Yan-Dutu went over to the side of the Chinese Dungans, even stipulating in his will that he be buried in the Dungan cemetery.

When an insoluble racial dispute arose, he proclaimed his inability to decide on whom he would bestow his sympathy, and he then staged a cockfight to settle the matter. For this purpose, Yan-Dutu kept several cocks of different colors. The ruler knew their qualities, and on the the day of the fight, he personally chose which of the cocks was to represent each of the opposing sides. The black cock might be a Dungan; the white, a Sart; a yellow cock, a Kalmuk. Thus, according to Dutu's wish, the favored nationality won through the seeming valor of the cock. Then the ruler, raising his eyes to heaven, proclaimed that his heart was open to all, but that destiny had awarded preference to the Sarts or Dungans, according to his needs on that particular occasion.

During our stay, this "Master of Philosophy" punished a god for the continuous drought. The god of water and rain was flogged. But since he still persisted in withholding rain, his hands and feet were cut off and he was drowned in the river. And in his place, a local "devil" was solemnly installed. Numerous methods of execution were apparently familiar to the "Master of Philosophy." He generously applied them to personal enemies and disobedient officials. In Octave Mirbeau's *Garden of Torture*, two subtle inventions were omitted: One was the insertion of a horse hair in the eyeball, with which the nerve was then sawed through. Alternatively, a disobedient official would be sent on a mission and overtaken by faithful men of Yan-Dutu, who would then plaster the official's face

with Chinese paper until he met his eternal rest. Stories are related of how the murders of undesirable statesmen were cleverly staged. For some reason, these usually occurred after a generous dinner, when the executioner appeared behind the victim and unexpectedly cut off his head. In Imperial times, it was also customary to inform the victim first that some new title had been awarded him!

In the streets of Urumchi marched a ragged crowd, with loud drumbeats and with innumerable bright banners that dispersed before one's very eyes, disappearing in the narrow alleys: This was the army of Yan-Dutu. An army is estimated by the number of caps, and for this reason we often saw two-wheeled carts carrying poles on which hung numerous soldiers' caps. An invisible army! And Yan-Dutu, drawing the pay for the number of caps enlisted, used cunning manipulations to send large quantities of silver through foreign representatives to far-distant banks. Incidentally, the ruler had no opportunity to use his wealth as he was killed by Fan, the Commissioner of Foreign Affairs, in 1928. It was strange in our day to see these medieval customs involving the terror of torture and deep superstition. New China must send specially educated men to its provinces.

And another custom greatly astonished us in Sinkiang. I refer to the open trade in human beings—children and adults. Already in Khotan we had been advised quite seriously not to hire servants, but to buy menservants and maids outright, as we were assured that this was much easier and much more economical. A good maid costs twenty-five sars, which is less

than twenty dollars. A groom may be bought for thirty sars. Children are quite cheap—two to five sars. In Toksun, a Cossack woman from Semipalatinsk who had married a Chinese, showed us a little Kirghiz girl, whom she bought for three sars. This was fortunate for the girl because the childless woman had bought her as a daughter. But more often, you hear of terrible hardship. Insufficient attention is paid to this sad fact as well as to the destructive habit of opium smoking. Distributors and addicts of this scourge should be subject to the most severe penalty if their consciences are so deadened that they cannot realize the crime they commit both towards themselves and towards future generations.

But let us not leave Chinese Turkestan with these dark impressions. Before me rise four pictures recalling ancient times:

A horseman rides along and on his hand, as in ages past, sits a falcon or a trained hawk with a small cap over its eyes.

In the desert we were overtaken by a traveling minstrel— a teller of legends and fairy tales—a Baksha. Over his shoulder hangs a long sitar, and in his saddlebags are several drums. "Baksha, sing us something!"—and the traveling singer, loosening the reins of his horse, sends out into the silence of the desert a song of Shabistan, of its handsome princes and its good and evil witches.

And another small, but significant episode: Between Aksu and Kuchar, near the town of Bai, a peculiar-looking individual in shackles asked to join our caravan. It appeared that the local authorities had given orders that this criminal be sent with our caravan. We forbade such an addition. The criminal slackened his pace and remained in the rear. But, for many days we could see him following the caravan far behind, without any guard.

About four miles out of Urumchi, a Chinese mafa over-
took us. It appeared that this Chinese, Sung, who had been in
our service as far as Khotan, could not let us go without at least
one more farewell. Before our departure he had wept for several
nights because the governor had forbidden him to accompany
us beyond Urumchi. And the kind heart could not resist the
desire to see us once more. It is always pleasant to remember
such people.

Beyond Urumchi there comes a strip of land, interesting not
only from an artistic but also from a scientific and ethno-
graphic point of view. In this region, kurgans, different types
of burial sites, and stone images still remain to tell of the great
migrations of peoples. On the other hand, these ranges of the
Tarbagatai mountains, especially since the revolution, are
infested with robbers. The Kirghiz, whose lands begin here,
although outwardly resembling the Scythians and indeed re-
minding one of silhouettes from the vases of Kul-oba, are of
little use in the present day. Their habit of robbing, "baranta,"
makes civilizing them rather difficult. Besides, there is plenty
of gold in the region of the black Irtysh and thus wandering
masses of prospectors have invaded the place. It is better not
to sit round the campfire with them.

One is again surprised at the fertility of the country and
how little it has been studied and exploited.

The Altai, or as it is now called, Oirotia, is equally remote
and neglected. The Oirots are a Finno-Turkic tribe at a very
low state of evolution. With their worn kaftans of sheepskin
and their unkempt hair, they looked like some of the Tibetans.
The Old Believers, who settled long ago in this remote coun-

try, are, of course, the only strong masters of the place. It was pleasant to see that the Old Believers have evolved considerably, rejecting many of their old religious prejudices. They now think about proper management, about American machines; and they welcome foreigners, although this was not previously the case.

Of course, the old way of living with its picturesquely carved wooden houses, with brocaded sarafans and old icons, has also disappeared. We wished that in the new forms of life, antiquity not give way to the vulgarity of the bazaar; for in Siberia, where there is such mineral wealth and other natural treasures, the people have the heritage of highly artistic Siberian antiques, the heritage of Yermak and fearless pioneers. When we passed the place on the Irtysh where Yermak, the hero of Siberia, was drowned, an Altayan said to us, "Never would our Yermak have drowned if it had not been for his heavy armor that dragged him to the bottom!"

Meeting the Old Believers in the Altai, it was astonishing to hear of the numerous religious sects which exist there even now.

The Popovtsy, the Bezpopovtsy, the Striguny, the Pryguni, the Pomortsi, the Netovtse (not recognizing any of the beliefs, but considering themselves of "the old faith")— how many incomprehensible discussions they occasion! And toward Trans-Baikal, among the Semeiski (Old Believers exiled to Siberia with their entire families), one also meets the Temnovertsy and the Kalashniki. Each of the Temnovertsy has his own icon, closed with little doors, to which he alone prays. If anyone else should pray to the same icon, it would become unfit! Still stranger are the Kalashniki. They pray before the icon through a little opening in a kalach (a loaf of bread). We have heard of many obscure beliefs, but beliefs

as strange as these we had never heard of—and that in the summer of 1926! Here there are also Hlysty, Pashkovtsy, Stundisty, and Molokans—a great variety of different beliefs which entirely exclude one another.

But even in these forsaken corners, a new conception is already beginning to stir. The long-bearded Old Believer speaks with enthusiasm of agricultural machinery and compares the quality of industrial production in various countries. Although the beliefs have not yet been completely obliterated, prejudice against innovation has already evaporated. Sound economic principles have not diminished but have encouraged new growth. This new build-up of agricultural methods, its untouched riches, its great radioactivity, there the abundance of its grass (which grows taller than a man on horseback), its streams, its inviting electrification—all this gives to the Altai an unforgettable meaning.

In the Altai one can also hear many significant legends connected with vague reminiscences of tribes that passed by here long ago. Among these obscure tribes are mentioned the "Blacksmiths of Kurumchi." The name indicates these people were fine metalworkers, but whence did they come and whither did they go? Perhaps the popular memory alludes to the creators of the metal objects for which the antiquities of Minusinsk and Ural are so famous. When one hears of these blacksmiths, one involuntarily recalls the legendary Nibelungen who drifted far to the west.

In this melting pot of nations, it is most instructive to observe how sometimes, under your very eyes, a language may be changed. In Mongolia, we heard of the most curious combinations of expressions, made up only recently from many languages. Chinese, Mongolian, Buryat, Russian, and slightly modified foreign technical words already afford quite

a new mixture. A new problem will arise for philologists from this creation of new expressions and perhaps even of entirely new local dialects.

The Altai played a most important part in the migration of nations. The burial places of huge rocks—the so-called graves of Chud—as well as the inscriptions on the rocks, all bring us back to the important epoch when, from the far southeast, impelled by glaciers or at times by sands, nations gathered and, like an avalanche, overran and regenerated Europe. From the prehistoric and historic point of view, the Altai is an untouched treasure; and the ruler of the Altai, the snow-white peak of Belukha, who nurtures all rivers and fields, is ready to yield her treasures.

If it was important to become acquainted with the Oirots and Old Believers, then it was still more important to study the Mongols on whom, at present and with good reason, the world turns its gaze.

They are the same Mongols whose very name impelled the inhabitants of the ancient Turkestan towns to flee their houses in terror, leaving behind an inscription: "God save us from the Mongols." And because of them, even fishermen in far away Denmark feared to venture into the open sea. Thus was the world awed by the name of the terrible conquerors.

When listening to stories about the Mongols, one is astonished by their irreconcilable contradictions. On the one hand, you hear that the Mongolian army chiefs even now, on capturing an enemy, cut out his heart and eat it. And one commander even stated that if you cut out the heart of a Chinese, he only grits his teeth; but the Russians scream; terribly. There are also

tales of Shaman conjurers and of how, in the darkness of the Shamans' yurtas, you can hear the trampling of whole droves of horses, the sound of coveys of eagles in flight and the hissing of innumerable snakes. At the will of the Shaman, snow falls inside the yurta. Such manifestations of willpower indeed exist. Incidentally, is it not possible that the word "Shaman" is a debased form of the Sanskrit "Shraman," just as "Bokhara" is simply derived from the Buddhist word "Vihara"?

In Ulan-Bator they related to us the following episode, showing the willpower of certain lamas: A certain man received word from a revered lama that after two years of prosperity, great danger would befall him if he remained in Ulan-Bator after a given date. Two years passed in great prosperity, and, as is often the case, the successful man entirely forgot the warning. Unexpectedly, revolution broke out and the opportunity to leave Ulan-Bator safely was missed. Terrified, the man hurried to the lama again. The latter, reproving him, promised to save him once again and ordered him to depart the next morning with his whole family. "But," he added, "should you meet soldiers, do not try to run away but remain absolutely motionless." The man did as the lama had instructed. On the way, a detachment of soldiers approached. The family stopped and remained silent and motionless. As the soldiers passed near them, they heard one of them say to another: "Look, what's that? People?"

But the other man replied, "What's the matter? Are you blind? Can't you see they're stones!"

When you visit the Mongolian printing press in Ulan-Bator and speak to the Minister of Education, Batukhan, and to the well-known Buryato-Mongolian scholar and honorary secretary of the Scientific Committee, Djemsarano; when you

become acquainted with lamas who translate algebra and geometry textbooks into Mongolian, you see that the seeming contradictions combine in the potentialities of the people who, with reason, turn toward their glorious past.

To the casual passerby, Mongolia reveals its outer self, which astonishes by its wealth of color, its costumes, its age-old traditions blended with brilliantly staged ceremonials. But on closer acquaintance, you will find among the Mongols serious scientific work, a careful investigation of their own country, and a desire to send their youth abroad to absorb the methods of contemporary science and technical knowledge. The Mongols go to Germany. They would also like to visit America, but the cost of the journey and of living there, and especially their ignorance of the language, are serious obstacles. I must say that during our stay in Mongolia we saw much good in the Mongols. Among many other things, I was pleasantly touched by their serious attitude towards the remains of Mongol antiquity, by their efforts to retain these monuments, and by their strictly scientific study of them.

The remarkable discovery by Koslov's expedition to Mongol territory opened a new page in the history of Siberian antiquity. Animal designs, which we had seen only on metal objects, were discovered on textiles and other material. In Mongolian territory there are large numbers of kurgans, kereksurs, so-called "deer-stones" and "stone images." All these await further study.

In Ulan-Bator, we had to decide on the route to be followed by the expedition. One possibility was to go through China for, in addition to our passport from the Peking government, Yan-Dutu had issued us a second passport exactly my height in length! But another circumstance intervened: In Ulan-Bator we met the representative of the government of the Dalai Lama,

Lobzang Cholden, who proposed that we go through Tibet. Not wishing to intrude, we asked him to confirm his invitation by the written consent of the Lhasa government. He sent two letters to the Dalai Lama in Lhasa through Tibetan caravans and also asked the Tibetan representative in Peking to communicate with Lhasa. Three months passed and Lobzang Cholden, who was also acting consul, informed us that he had received a positive reply via Peking and that he could issue the official passports to us and give us a letter to the Dalai Lama. As we learned afterwards, these passports were indeed entirely valid. Under the circumstances, we naturally preferred to go through the Gobi and Tibet, instead of risking chance attacks by the Hunhuses in China.

A curious incident should be mentioned. When we were preparing to depart, my son George, drilling our Mongols in the use of their rifles, took them to the outskirts of the town. As they crept up one slope, it turned out that on the other side a Mongolian infantry detachment was going through the same drill. The sight of both sides meeting each other unexpectedly on the ridge of the hill was most extraordinary. This drill proved to be by no means superfluous—as our later encounters with the Panagis proved.

On 13 April 1927 our expedition, with the assistance and good wishes of the Mongolian authorities, set out in a southwesterly direction towards the Mongolian frontier post, the Yum-Beise monastery.

Part of the way from Urga—now called Ulan-Bator—to Yum-Beise, we covered by car. The heavily laden automobiles looked like tanks, and, on the top, attired in yellow, blue, and red, with conical caps, sat our fellow travelers, the Buryat and Mongol lamas.

At first we intended to use cars beyond Yum-Beise, too.

The people told us that we could easily cross the Gobi in them. But this was untrue. The six hundred miles, more or less, to Yum-Béise we covered with difficulty in twelve days, on some days doing no more than ten to fifteen miles because of breakdowns and difficulty in fording rivers and crossing stony ridges. Even here, there was no real road. Occasionally there was a camel path, but most of the way was through virgin land and we had to scout. Two conditions must be remembered: The first, that all existing maps are very vague; the second, that one cannot really trust the local guides. Our guide, an old lama, took us not to the present-day Yum-Beise, but to an ancient destroyed city fifty miles to the west. The old man had been confused!

It was evident that we had to abandon our cars in Yum-Beise. From the local monastery, we engaged a caravan that undertook to take us in less than three weeks to Shih-pao-ch'eng, between Ansijau and Nanshan. The road from Yum-Beise to Anhsi was interesting because no traveler before us had used it. It was instructive to investigate how fit it was for travel: water supply, fodder, and safety. Only the old lama from Yum-Beise knew this road. He assured us that this direction was far better than the other two, one of which is roundabout from the west and the other along the present Chinese road to the east. Recommending this way, he insisted that the one danger of this road—namely the powerful brigand Djelama—had been killed by the Mongols two years earlier. And, indeed, in Ulan-Bator we had seen Djelama's head preserved in alcohol and had heard many tales about this remarkable man.

The Mongolian deserts will guard the legends about Djelama, but no one will ever ascertain what inner motives impelled his strange actions. Djelama, a man of unusual ability, graduated in law from a Russian university. He then

went to Mongolia, where he distinguished himself by his activities against the Chinese. He then spent several years in Tibet, studied Lamaism, and also the control of willpower for which he was naturally equipped. Returning to Mongolia, Djelama received the title Gun, the title of a Khoshun prince. But he got into difficulties with a Cossack officer and soon found himself in a Russian jail. During the revolution of 1917, he was released. Then followed invasions and activities within Mongolia, after which he gathered round himself a large body of helpers and built fortifications in the Central Gobi, using as laborers the prisoners from the many caravans he had captured. In 1923, a Mongolian officer approached Djelama as though offering him a friendly gift of a khatik. But under the white silk scarf was a Browning and the ruler of the desert fell dead, pierced by several bullets. The head of Djelama was carried on a spear around the Mongolian bazaars. After a while his men scattered.

With some excitement, our caravan approached the place where the city of Djelama stood. On the stony slope from far away one can see the white Chorten, made of pieces of quartz— proof of how Djelama made his prisoners work. The lamas advised us to dress in Mongolian kaftans in order not to attract the attention of any undesirable people we might meet. Tempei-Jaltsen, the city, had to be quite near. In the dark night we encamped. Next morning before sunrise we heard an unusual commotion. People were shouting, "Look, the city!"

We all rushed from our tents and behind the next sandy hill we clearly saw the towers and walls. Neither the Buryats nor the Mongols would agree to go and investigate what was in the city. So George and Porten, carrying carbines, went alone. The rest waited, ready for battle, watching with field glasses. Shortly afterwards the two were seen on a tower. This was the

sign that the city was deserted. During the day, the entire expedition visited the city in several groups. We were all amazed at Djelama's fantasy in laying out a completely fortified city in the midst of the desert! Certainly this was no mere brigand! Many songs are being sung about him. And his men have assuredly not disappeared.

The next day some suspicious-looking riders approached our caravan inquiring about the quantity of arms we were carrying. Apparently, the reply did not encourage them and they dispersed behind the hills.

The regions of Mongolia and the Central Gobi await explorers and archeologists. Of course, the discoveries of the Andrews Expedition and the last expedition of Sven Hedin, judging by news accounts, gave excellent results. But the place is so vast that not one, not two, but many expeditions would be needed to completely cover it.

On the way, we encountered many beautiful pieces of so-called "deer-stone,"—tall menhir-like granite or sandstone blocks, sometimes ornamented. We also saw numbers of unexcavated kurgans, large and carefully constructed. The base of each kurgan was symmetrically surrounded by rows of stones, and on the top there were also stones. Near the kurgans, as if forming a second row, were small stone elevations. Especially interesting were the stone "images" of exactly the same character as those of the southern Russian steppes.

In one case there was a long row of oblong stones extending almost a whole mile up to a stone "image," facing east. We noticed that the carvings are still smeared with grease and we heard a legend that one of the images depicted a powerful brigand who, after his death, was transformed into a protector of this place. Our Tibetan, Konchok, assigned to us as an attendant by the Tibetan representative in Ulan-Bator, ad-

dressed long prayers to the protector of the region, requesting a happy journey for us. In conclusion, he threw a handful of grain at the image.

Draw a line from the southern Russian steppes and from the northern Caucasus across the steppes of Semipalatinsk, the Altai and Mongolia, and then turn south, and you will have the main artery of migration.

The twenty-one days of our journey from Yum-Beise to Shih-pao-ch'eng passed in complete solitude. Apart from two or three forsaken yurtas, the destroyed city of Tenpei-Jaltsen, and half a dozen suspicious riders, we met only one caravan, which crossed our path on its way from Karakhoto to Hami. The encounter with this caravan almost turned out tragically, for the Chinese head of the caravan, mistaking our campfires for Djelama's encampment, became alarmed and fired a shot at us from his only rifle.

One thing was quite clear: The direct road from Yum-Beise to Anhsi-chou provides enough water and fodder for the camels and is at present quite safe, although stories of recent robberies are still plentiful. We rejoiced to find in the Gobi so many most interesting subjects for paintings. First, the distant ranges of the Chinese Altai mountains, then the auriferous Altyn-Tagh offers such vivid color combinations. One does not see the merciless depression of the Taklamakan, but the multicolored stone surfaces lend a decisive, resonant tone. All the springs and wells were in good condition, except one, which was blocked by the carcass of a khainyck (a kind of yak). Throughout the journey, beginning with Ladakh, the question of water was always important. Most of the crystal-

line streams were filled with carcasses of dead animals; and in the ponds of towns in Sinkiang, such refuse floated that the greatest thirst could not have induced us to drink this concoction.

Outside of Mongolia, we were astonished everywhere by the frequency and monstrous size of goiters that are caused by the water. We could not ascertain to what extent the boiling of water helps to obliterate this evil, but certainly this terrible prevalence of goiter must greatly undermine the working capacity of the population.

The clay walls of Anhsi-chou appeared in the distance. A narrow strip of orchards was set near the great Chinese road that leads from Anhsi-chou to Suchow, and we entered the mountain ranges of Nanshan. There already appeared the yurtas of Mongols who belonged to the Kukunor district. Flocks of cattle were seen. Then the clever elder of the village, Machen, appeared; and, under various pretexts, extracted quite a lot of money from us. He especially cheated us in exchanging Chinese dollars to Tibetan norsangs. We had to buy animals for our new caravan because the lamas from Yum-Beise were returning home. We also had to buy provisions. Machen assured us that he could sell only for Tibetan norsangs, which he said were far more valuable than Chinese dollars. But it turned out afterwards that the opposite was true and that the value of norsangs was much lower.

I will not pause to give particulars of how five of our Buryats, turning insane without apparent reason, went to denounce us to the representative of the Sining Amban who happened to pass us on the way. The Buryats told him that we were crossing Chinese territory without a Chinese passport and that, for some special purpose, we went around Anhsi-chou without entering it. The result of this libel was that the

grey-haired Dungan in his red turban personally came to our camp with fifteen soldiers and, after a long conversation, asked to inspect our passports. We satisfied his wish and explained that Anhsi-chou was simply not on our road. The old man became very friendly and offered to beat our accusers with sticks. The slanderers were driven away and their places easily filled by local Mongols.

Of the Mongols of the Kukunor district whom we met during our stay at Shih-pao-ch'eng and then at Sharagolji at the foot of the Humboldt ridge, I can say only good things. When we approached Shih-pao-ch'eng, we met the first Mongol from Kukunor, Rinchino, who raised both hands upwards and greeted us with an unforgettably heartfelt gesture. Under the same happy sign we lived with the Mongols and later parted from them. No difficulties, no quarrel did they bring to our caravan. True, after our encounter with the Panagis, the old Senge Lama got frightened and wanted to leave us. He was terrified and murmured something in such a friendly way that he at once allowed us to dissuade him.

When speaking of the Mongols, it is necessary to point out some signs of an ancient physical bond between America and Asia. In 1921, when I became acquainted with the Red Indian pueblos of New Mexico and Arizona, I was forced to exclaim repeatedly, "But those are real Mongols!" Their features, details of their dress, their way of riding, and the character of some of their songs, all carried me away in imagination across the ocean. And now, having the opportunity to study the Mongols of outer and inner Mongolia, I was involuntarily reminded of the Pueblo Indian. Something inexplicable, fundamental beyond all superficial theories, unites these two nations.

From the Mongols I heard a fairy tale that emanated from the heart of Mongolia. In poetic form, it related how there

lived two brothers on neighboring pieces of land and how greatly they loved each other. But the fiery Dragon underneath the earth stirred, and the land split and separated the two brothers. Their souls yearned for each other. So they asked the birds to carry their message to their kin. And now they await the heavenly, fiery bird that will take them across the precipice and unite them. So the peoples, through symbol and poetry, transmit the tale of cosmic upheaval.

With me I had many photographs of the Indians of New Mexico and Arizona, and I showed them in faraway Mongolian encampments. And the Mongols exclaimed, "But those are Mongols!" The separated brethren recognize each other!

In the lonely yurtas of the Kukunor Mongols one is especially surprised at the paucity of household utensils. Their dress is most effective. Their kaftans remind one, in their picturesque folds, of the Italian frescoes of Gozzoli. The women, with their many braids adorned with turquoise and silver ornaments, wearing their red conical hats, look extraordinarily decorative. From their distant encampments, the Mongols came riding on their small horses to visit our camp. They looked in amazement at our photographs of New York skyscrapers and exclaimed: "The Land of Shambhala!" and they rejoiced at every pin, button, or empty fruit tin. Every little household article is a real object of pride for them. And the hearts of these men of the desert are open towards the future!

When the heat of the day grows intense, the guide of the caravan begins to whistle quietly some strange melody. He is calling the wind! What a wonderful subject for the theater: "The Whistler of Winds"! One also meets the same custom among the traditions of ancient Greece.

In Sharagolji, together with all the Mongols of the neigh-

borhood, we experienced the calamity of a flood from the hills. It was the end of July and our camp was near a very small and seemingly most peaceful stream. For three successive nights, from the direction of Ulan Daban on the Humboldt ridge, we heard an inexplicable, continuous dull noise. We thought it was the wind. But on 28 July at 5 p.m., when we were about to begin dinner, down the gorge came tremendous torrents, transforming the peaceful little stream into a muddy rumbling force and flooding the whole neighborhood with waves about three feet high. The power of the flood was tremendous. Our kitchen, the dining tent, and the tent of our Buryats were carried away in no time, with all their contents. Our boxes were carried downstream and George's tent was flooded knee-deep. A great variety of our things disappeared in the water, never to be found again. The yurtas of the local Mongols were also destroyed or severely damaged. About two hours later, the river fell and next morning we saw a wet site, entirely transformed. Instead of the barkhans, there were deep, water-eaten holes; and instead of level places, new heaps of sand and stone.

This incident once more confirmed our observations of the alluvial layers of central Asia. In investigating the profiles of the soil, one is surprised at the comparatively recent origin of many of the upper strata and also at their strange mixture. But such characteristic disturbances as we ourselves have witnessed easily change the profiles of the surface. During excavations, such conditions may cause much surprise.

On 19 August 1927 our caravan preparations were completed. The camels, nourished by the grass and bushes, had by then begun to grow new wool. We started across Ulan Daban, deciding to cross dangerous Tsaidam by the shortest route, thus establishing a new path over Ikhe-Tsaidam and Baga-

Tsaidam to the Neiji Pass. This new route spares the traveler the western road to Makhai, which is so perilous for caravans because of its scarcity of water, and also the eastern roundabout way, which is very long and is usually followed by the pilgrims to Lhasa. We were warned that three days of the march would be unpleasant and dangerous and that for the last twenty-four hours we would have to proceed without a stop because stopping on the thin surface of the salt deposits is not only dangerous but useless since there is no forage for the animals there. Crossing Tsaidam, we at once became convinced that the complete green outline on the maps does not correspond to reality. The same inaccuracy is also apparent in regard to the names of villages, etc. These places each have a Chinese, Mongolian and Tibetan name, all of which are quite different. Naturally only one of these names appears on the maps, depending on the nationality of the interpreters accompanying previous expeditions. But especially strange are the European names superimposed on ancient places that have long had their local names. The European names of the mountain ridges of Marco Polo, Humboldt, Ritter, Alexander III, and Prejevalski have, of course, no meaning for the local population who have had their own names for these ridges since time immemorial.

Another original circumstance militates against obtaining precise names. The Mongols and Tibetans believe that one should not pronounce the names of places in the desert; otherwise the gods will be attracted by the name and become angry.

We also had to add to our maps mountain ridges, sandy plains, and dry land covered with sharp blocks and gaping black openings of swampy water.

Grassy marshlands are characteristic only of the lakes of

Ikhe and Baga-Tsaidam. Fat horses belonging to the Tsaidam prince graze on the rich meadows. I must mention that the Tsaidam prince, who has had some altercations with travelers, showed us only friendship and even wrote to offer us his camels up to Lhasa, but by that time our caravan was already assembled.

The crossing of the salt surface of Tsaidam deeply impressed us all. Apparently our guides were fully aware of its dangers although the season was a favorable one since there are few flies and mosquitoes and very little water in autumn. It felt strange to cross the waterless sandy desert, knowing that to the west lay the Kun-Lun upland that has been so little explored. By and by, the sand changed into hard deposits of salt, a heritage of the lake that was here before. The caravan entered a seemingly endless cemetery of massed sharp salt slabs. The most dangerous part was crossed in darkness and then in moonlight. The Mongols shouted, "Don't move from the path!" Indeed, on both sides, among the sharp edges of the salt slabs, could be seen gaping black holes. Even the road was full of holes where the animals could easily have broken their legs. The horses walked with great caution. Only one camel fell through the crust. It was pulled out with great difficulty. By morning, the salt slabs were gradually replaced by whitish, powdery residue and then the sand began again. Soon the first bushes and tall grass appeared and were greedily devoured by our hungry animals. Far in front of us, in blue tones, appeared the mountains. This was Neiji, the geographical border of Tibet, although the frontier outposts were much farther.

To cross the blue mountains we went through the comparatively fertile region of Teijinor, meaning the land governed by the Council of Elders. The vegetation seemed rich and the fields were cultivated, but still we noticed deserted encampments and in the few yurtas we observed commotion.

It appeared that a war was on between the Mongols and the Goloks who lived behind Neiji. We were told that on the road we would see dead bodies. And the people awaited with trepidation attacks from Tibetan bandits.

There were even vague hints about an attack against our caravan. We recalled the strange incident in Sharagolji: One evening a Mongol came galloping up to our tents at full speed. He was dressed with extraordinary richness. His gold-embroidered costume and his yellow hat with red tassels were most impressive. He quickly entered the nearest tent, which was our doctor's, and, speaking in haste, said that he was our friend and that on the Neiji Pass fifty hostile horsemen were waiting for us. He advised us to go cautiously and to send a patrol ahead. He left as quickly as he had entered and galloped away without revealing his name. Now, as we heard the stories about the Panagis and Goloks, we recalled this unexpected, friendly warning.

On the following day, we saw three dead Mongols and the carcass of a horse on the road. On the sandy surface, traces of furious galloping were clearly visible. Taking military precautions, we moved at first along the river Neiji and then toward the Neiji Pass. In a valley covered with thick bushes three of us noticed the silhouette of a rider, and we found a recently built fire and a pipe. We decided not to advance toward the usual pass, a very sandy one with obstacles, but to change our route and to use the next pass a few miles farther, which bears the same name. This unexpected decision turned out to be our salvation.

The next morning we started out before sunrise. Mrs. Roerich, who has an extraordinarily sharp ear, heard the distant barking of a dog. But everything remained still. We were

about to descend into a narrow gorge between two hills when, peering sharply into the morning mist, we noticed the silhouettes of riders in the gorge. We could distinguish long spears and rifles with gunrests. They were lying in wait for us at the end of the gorge. But instead of moving on, we retreated to the top of the hill and thus held a commanding position, surprising the enemy. Behind us came our Torguts, the best marksmen. From the top of the hill, we saw a group of horsemen and, securing our most advantageous position, we sent our Mongols to warn them that, should they continue hostilities, we would spare neither their lives nor their yurtas. The negotiations were successful.

The Panagis spoke of having sent for fifty horsemen, and a few hours later we saw their herds coming back from the mountains to their yurtas, which meant that measures had been taken just in time. The next day, in full battle formation and followed by suspicious–looking horsemen, we crossed the Neiji Pass. Here a terrible thunderstorm broke out with heavy snowfall, which was quite unusual for the month of September. The Mongols said, "The Mountain-god Lo is angry because the Panagis intended to harm great people. In the snow they will never attack us because traces would remain on the ground."

In front of us was the Marco Polo ridge, the stern Angar-Dakchin, and, beyond, the picturesque Kokushili and the mighty Dungbure. One might write an entire volume telling of these places alone; of the huge herds of wild yaks numbering many hundreds; of white-collared bears that come up most trustingly; of wolves attacking wild goats and antelopes. One is amazed at the sight of mineral springs, hot geysers, and other unusual phenomena.

From Tsaidam, which is eight to nine thousand feet high, we ascended the Tibetan upland to about fourteen or fifteen thousand feet.

Here there occurred characteristic episodes in our negotiations with the Tibetans, which I will now describe:

On 20 September our caravan noticed with some excitement the tent of the first Tibetan post. Several ragged people in dirty sheepskin kaftans approached us and demanded our passport. In the presence of many witnesses we handed them our Tibetan passport and they allowed us to proceed. The passport was sent to their chief.

On 6 October the Tibetans proposed that we stop in a small place named Shindi to await further authorization from the Tibetan General Khapshopa, the high commissioner of the Hors and the commander of the northern Tibetan frontier. Two days later our camp was moved closer to the general's headquarters on the river Chunargen.

This place will forever remain in our memory. The cheerless upland, arctic in character, was full of small mounds and was bordered by the drear outlines of scree slopes. The general's first welcome was the height of kindness and friendliness. He told us that, in consideration of our passports and letter, he would permit us to proceed to Lhasa via Nagchu. Nagchu is the northern fort of Tibet and is three days from Chunargen. The general asked us only to stop for three days and to move our camp nearer to his headquarters as he wanted to personally inspect our things. "The hands of small people," he explained, "should not touch the belongings of great people!"

He then said that he would remain with us until the permission to proceed arrived, and in my honor he ordered a special solemn retreat to be played by his band every evening. Appar-

ently, the general had more musicians, with drums, clarinets, and Scottish bagpipes, than soldiers. When we visited him, they gave us a cannon salute and paraded all their banners. The strange soldiers in dirty jackets with torn buttons, held their rifles in everywhich direction. In all, our meetings with the general were very friendly, and he was probably not guilty of what followed. When a week passed, still without reply, the general informed us that he had to depart on duty but that he was leaving a major and five soldiers with us and would give all necessary instructions to the local elders of the Hors.

The general left, and instead of three days, we remained in this dismal place, at fifteen thousand feet, for five months. The situation became catastrophic. A severe winter set in with whirlwinds and snow. What had happened we could not discover, for all letters sent by us to the Dalai Lama and the governor of Nagchu were returned to us, often torn up. We repeatedly wrote to the American consul in Calcutta; to Colonel Bailey, the British resident in Gangtok; and to our institutions in New York, requesting the governor of Nagchu to send all these messages by wire from Lhasa to India. And we were told that the telegraph between Lhasa and India no longer existed—a downright lie!

Through the major, we asked permission either to turn back or to proceed to the general's headquarters, but they refused us permission either to go forward or back as if they actually wished our destruction. Our money was exhausted. Of course, the American dollars we had with us were absolutely useless. Moreover, we had no more medicine and our provisions were at an end. Under our very eyes, the whole caravan perished. Each night the freezing, starved animals approached our tents as though knocking for the last time

before their deaths. And in the morning we found them dead near our tents. Our Mongols dragged them beyond the camp where packs of wild dogs and condors and vultures were already awaiting their prey. Of 102 animals, we lost 92. On the Tibetan uplands, we also left the bodies of five of our fellow travelers: three lamas—one Buryat and two Mongols—then Champa the Tibetan, and finally the Tibetan major's wife, who died of inflammation of the lungs. Even the natives could not withstand the severe conditions. Our caravan had only summer tents as we never imagined we would pass the winter in Chantang, which is considered the most severe site in Asia.

Mrs. Roerich's pulse reached 145 and our doctor called it "the pulse of a bird." My pulse was 130 instead of the usual 64. The pulses of George and the two Bogdanovas remained about 120. The doctor prophesied the most sombre outcome and wrote medical certificates stating that to detain an expedition under such conditions was tantamount to attempted murder.

Of this stay in Nagchu I could write a whole book full of the saddest reminiscences.

There were two governors of Nagchu, one of them considered a trusted aide of the Dalai Lama and himself a lama, although he had a family. To describe them, it is sufficient to relate two short episodes that they themselves told us:

One episode concerns General Laden-La, a general of the Tibetan army, an undoubtedly gifted personality to whom, at one time, was entrusted the reform of the mixed troops of Tibet. The lama-governor informed us that Laden-La had been dismissed from the army because he introduced "red" customs by recommending European uniforms for the soldiers and ordering the men to salute their officers.

The same governor explained the Russian revolution thus: "There lived a man named Nenin who did not like the white

Tsar. Nenin took a pistol and shot the Tsar and then climbed a high tree and proclaimed that the customs would be red and that the churches would be closed. But there was a woman, sister of the Tsar, who knew both red and white customs. She took a pistol and shot Nenin!"

It would be too long to relate all our negotiations with the drunken major and later with the governors of Nagchu. In any case, on 6 March we finally started for India, compelled to go by the most difficult, circuitous route. With us we also took such unanswered questions as how the government of Lhasa could refuse to recognize the passport issued by its own official; whether one could detain a peaceful American expedition with three women members an entire winter in summer tents at the most disastrous heights; and why it was necessary for the Tibetans to imperil our health, starve the entire caravan to death, and destroy all our cinema films through acute changes of temperature.

Chantang—the northern upland of Tibet—truly deserves its fame as the coldest spot in Asia. Terrific storms increase to a tremendous degree the effect of the frost, and the rarefied atmosphere at fifteen to sixteen thousand feet makes the conditions exceptionally severe. One may imagine the temperature when our brandy froze in a closed bottle! What temperature is required to freeze strong alcohol? Of course, by eleven o'clock in the morning the sun warms the atmosphere considerably, but, after sunset and at night, and especially in the early hours before sunrise, the frost is unbearable. Our doctor had the unusual opportunity of investigating, from a medical point of view, the conditions on these unique uplands.

After Nagchu-Dzong we followed the Tengri-Nor to Shentsa-Dzong and then crossed several passes to Saga-Dzong. From there we went along the Brahmaputra River to

the border of Nepal at Tingri-Dzong. Shekar-Dzong and Kampa-Dzong were the last points on our two-and-a-half month journey to the Himalayan pass, Sepo La. After crossing Sepo La, we descended by way of Thangu to Gangtok, the capital of Sikkim, where we were greeted most heartily by the British resident, Lt. Colonel Bailey, his wife, and the Maharajah of Sikkim. On 26 May 1928 we arrived in Darjeeling, staying once again in the villa Talai-Pho-Brang to compile the artistic and scientific material we had gathered.

Now let us cast a brief glance at the characteristics of contemporary life in Tibet and at its art:

Tibet offers the most astonishing combination of contradictions.

On one side, we saw profound knowledge and remarkably developed psychic energy. On the other, complete ignorance and limitless darkness.

On one side, there is devotion to religion, even in its limited form. On the other side, we noticed how the money donated to monasteries was concealed and how false oaths were given in the name of the "Three Pearls of the Teaching."

On one side, we saw respect toward women and their exemption from hard work. On the other side, there exists the institution of polyandry, so absurd in our times; it is strange to think that polyandry can exist side by side with Buddhism, even in its lamaistic form.

On one side, we saw instead of palaces, poor clay huts. But, on the other hand, the Tibetan governors, unashamed of such hyperboles, call these huts beautiful, snowy palaces.

On one side, the government of Lhasa calls itself the "gov-

ernment victorious in all directions." But on the other side, we see this inscription only on the miserable copper coins—the sho. We saw neither gold nor silver, either in the dzongs or in the hands of the people. It is also curious that the half and quarter sho, which are also copper, are larger than the sho itself. The entire population prefers silver rupees or silver Mexican dollars to their own Tibetan sho. The people even quote two prices when selling goods: a higher price if payment is made in Tibetan shos and a considerably lower one if paid in rupees and Chinese silver. But with Chinese silver it is not always easy either. In some places they demand Imperial coins; in other places, the Republican coins with six letters, or with seven, so that a whole assortment of various currencies is required.

But we were not surprised, as we had been accustomed to strange currency since our visit to Sinkiang, where the wooden tokens issued by the gambling houses in some places are valued more highly than the local paper money. In Sinkiang, the greater part of the notes often consists of advertisements for soap and other products glued underneath. We even received such notes from the government treasury; the neighboring Amban admitted they were not valid.

The entire life of Tibet seems composed of contradictions.

After the picturesque cities and monasteries of Ladakh, we looked in vain for something more beautiful in Greater Tibet. We passed ancient dzongs, monasteries, and villages. If from afar the silhouettes at times look good, as we approached, we were grieved to see the poverty and shoddiness of Tibetan structures. It is true that on the mountains and along the river-bed of the Brahmaputra are towers dating from the time of the ancient Tibetan kings. In these structures, one feels the power of creative thought. And one frequently sees these ruins. Near

them are usually the remains of once-cultivated fields. But that is all of the past. It all speaks of a life now gone, disappeared.

Saga-Dzong is a poor village with brittle clay walls. Black tents, like spiders, are pitched on long, black ropes. And like a spider's web over the village hangs a mass of torn and dirty flags. There is as much dirt as in Nagchu-Dzong. I remember how in Nagchu when we pointed out the dreadful dirt of the city, an administrator, the donier of the governor, replied, "If you consider this dirty, what would you say of Lhasa?" Tingri-Dzong, though considered the largest fortress on the Nepalese frontier, amazed us by its wretchedness and uselessness for defense. Tinkiu, Shekar, and Kampa-Dzong are impressive only insofar as some parts are left from ancient times. But the things of antiquity decay and are replaced by clay walls. Dzong-pens, the commanders of the castles, no longer live on the summits, but seek shelter lower on the slopes.

Regarding the local life, our compulsory five–month stay in the land of the Hors and the long journey in northern, western, central, and southern Tibet provided us with a mass of material. For the first time, an expedition had no need of an interpreter as even the Tibetans themselves affirm that George knows Tibetan better than Sir Charles Bell, who is considered an authority on the language. Without personal knowledge of the language, it is, of course, rash to judge the conditions of the country. The journey from Chunargen to the Sikkim frontier might fill an entire volume.

We went on so-called Urton (locally hired) yaks. Mentally, we reviewed the entire vista of contradictions between the people and the officials of Lhasa. And the impression strengthened that some of the lamas and the people are on one side and the group of Lhasa officials are on the other. Of the

latter, even the Tibetans themselves said that "Their hearts are blacker than coal and harder than stone."

We set up our camp not far from the camps of the Golokis. Each camp distrusted the other. The entire night one could hear the call "Ki-hoho!" from the side of the Golokis, and our Hors' reply "Khoi-khe!" Thus, through the entire night they warned each other of the sleepless vigilance of the camp.

In Tingri-Dzong, which is considered the second largest fort after Shigatse, our chief-of-transport discovered on one of our yaks a strange object wrapped in red silk. We investigated his discovery, and it turned out that an arrow had been sent with our caravan. Around the arrow was wrapped an order for mobilization of the local troops to suppress a riot in Poyul in eastern Tibet. Instead of sending the urgent order by special courier, the people attached the order to the yak of a private caravan that may perhaps do but ten miles a day.

Near Saga-Dzong, the elders refused to recognize the passport of the Dalai Lama sent to us from Lhasa. They stated that they had nothing in common with the government of Lhasa. We remember so many similar episodes taken from life and recounted them around the caravan campfires while the Tibetans ate their raw meat.

The Dalai Lama is regarded as an incarnation of Avolokiteshvara and a guardian of the true Teaching of Buddha. At the same time, throughout Tibet one hears a prophecy emanating from the Tenjye-ling monastery stating that the present and thirteenth Dalai Lama is the last one.

Concerning the omniscience of the Dalai Lama, many funny stories are told by the people and the lamas. For instance, a high lama who had free access to the Dalai Lama once visited him and had just put his foot through the door when the Dalai Lama asked, "Who is there?" Then the lama stretched his hand

inside the door. Again the Dalai Lama asked, "Who is there?" Thereupon, the lama entered with a bow, saying, "Your Holiness uselessly troubles to put this question. In accordance with your omniscience you should have known who was behind the door."

During our negotiations with the governors of Nagchu, in answer to their queries, we told them several times, "But you have a state oracle in Lhasa. Why not ask it about us?" Whereupon both governors looked at each other and laughed.

An entirely different attitude may be noticed everywhere toward the Tashi Lama, whose name is always pronounced with deep reverence.

"The customs of Panchen Rinpoche are entirely different," the Tibetans would say.

The Tibetans await the fulfilment of the prophecy about the return of the Tashi Lama, when he will reconstruct Tibet and the precious teaching will again flourish.

People everywhere speak of the flight of the Tashi Lama from Tibet in 1923 with special significance and reverence. They tell of remarkable incidents which accompanied this heroic exodus. It is said that when the Tashi Lama was being pursued near the northwestern lakes, the armed detachment from Lhasa almost overtook and captured him. A long road around the lake faced the Tashi Lama, and his men became troubled. But the spiritual Leader of Tibet remained undisturbed and gave instructions that the caravan should stop overnight before going round the lake. During the night, a severe frost set in and the lake was covered by thick ice over which they crossed the next day, thus shortening their way considerably. In the meantime, the sun rose, the ice melted, and when the pursuers reached the lake, it was impossible to cross and the Lhasa detachment was detained for several days.

Following the road indicated to us, we went for some time along the way by which the Tashi Lama had fled, and it was significant to hear the rumors of the people and the general anticipation of the return of the spiritual ruler of Tibet; for it is the Tashi Lama whose name is connected with the conception of Shambhala.

The Tibetans themselves tell you all this and point out that the Lhasa officials allow neither the people nor the religion to prosper.

Let us glance at several pictures from life in order to understand how the present state of religion in Tibet needs purification.

Here high lamas make their financial calculations on their sacred rosaries. Is this permitted? They use watermills and windmills to turn their prayer wheels and even clockwork, thereby releasing themselves from expending any energy. Does this represent the commandment of Buddha?

Not far from the government dzong stands the object of the latest idol worship—a tall stone smeared with fat. It appears that the Lhasa government itself has sanctioned this place of prayer in honor of the government oracle!

It is prohibited to kill animals. This is splendid. But the storerooms of the monasteries are filled with carcasses of mutton and yak. We were told of the sinless method of killing cattle—driving the animals to the edge of steep cliffs where they fall and kill themselves.

In the corner of a shop sits a lama, the owner, turning his prayer wheel. On the wall are images of Shambhala and Tsong-Kha-Pa. And right next to them are huge earthen pots full of the local wine that the lama makes to intoxicate his people.

Someone connected with a high personage offers to sell us a talisman with "complete guarantee" of its invulnerability

against firearms. He offers it to us for three hundred rupees. In view of the complete guarantee he offers, we suggest that the fortunate owner should try it out on himself. But the believer from Lhasa proposes to convince us with the aid of a goat, continuing to assure us of the miraculous powers of the talisman. When we do not agree to let him try it on the poor goat, the Tibetan walks off indignantly.

To deprive a criminal of further incarnations is considered the severest form of punishment. To effect this, the heads of the worst criminals are cut off and dried in a special place where an entire collection of similar remains is preserved.

Near the sacred mendangs and temples are scattered dead dogs, and sacred inscriptions are covered with human excrement and strewn over the road and on the fields. Many stupas have collapsed and many temples have been forsaken.

Not far from Lhasa is a place where corpses are hacked apart and thrown to vultures, dogs, and pigs to be devoured. It is customary to roll naked on these remains to preserve one's good health. The Buryat Tsibikov, in his book on Tibet, assures his readers that His Holiness, the Dalai Lama, has himself performed this absurd ritual.

Most remarkable is the testimony of the Tibetans about "Rolang"—the resurrection of the dead. Everywhere, one hears of "revived corpses which jump up and, possessed of extraordinary strength, kill people."

The Tibetans claim that whoever poisons a person of high estate himself receives the wealth and happiness of the poisoned person. There exist families in which the right to poison is handed down as a privilege of birth. These families preserve the secret of a special poison. For this reason, friendly Tibetans always advise one to be extremely cautious with other people's food. One sometimes hears of cases where people

were poisoned with tea and food that was sent to their homes as a sign of special esteem. This reminds one of old tales of poisoned objects, especially rings. We saw daggers and rings with special devices for carrying poison.

One can mention many such pictures from the real life of Tibet. They all reveal how many aspects of the religion must be cleansed and reformed. But we know many very distinguished lamas, and we hope that they can effect an enlightened reform of Tibet.

"Why do our people lie so much?" worries a Tibetan on the banks of the Brahmaputra. This vice, too, must be erased.

It is said that the Tashi Lama is, at present, in Mongolia, thus confirming a Mandala of the Buddhist Teaching. From this, one should expect good results as Tibet is in very great need of spiritual purification.

In speaking of religions in Tibet, one should also mention the Black Faith, inimical to Buddha. As we were able to see for ourselves, in addition to the Gelugpa, to the Red Hat sect of Padma Sambhava, and many other branches, the Bonpo, or Black Faith, is also present throughout Tibet. And it is much more widespread than one would imagine. We have even heard that Bonpo is on the increase. We saw a great many monasteries of the Bonpo in different parts of Tibet. They are all apparently very wealthy. In Sharugen, we were received most cordially at the Bonpo monastery and were even admitted into the temple and shown the sacred books. George was offered the opportunity of reading them. But then suddenly, the attitude changed. It appeared that the Bonpo had heard of our interest in Buddhism and therefore regarded us as their enemies.

The Bonpo say that the Buddhists are their enemies. Buddha is not recognized and the Dalai Lama is considered only

a temporal ruler. The ceremonials are conducted in a way contrary to those of the Buddhists. The sign of the swastika is represented in an inverted direction. The processions in the temple walk away from the sun. Instead of Buddha, another protector is represented whose biography coincides strangely with the life of Buddha. The Bonpo have their own sacred books. It is a pity that the literature of the Black Faith has been studied so little and that their sacred books have not yet been translated. One cannot refer to these ancient traditions lightly when they speak of their mysterious "Gods of swastika." The ancient solar and fire cults are undoubtedly the basis of Bonpo, and one must carefully examine these old, half-erased traces.

With regard both to Bonpo and to its archaeological remains, Tibet has not yet been sufficiently explored. We especially rejoiced at discovering typical menhirs and cromlechs in the Trans-Himalayan region of Tibet. You can imagine how remarkable it is to see the long rows of stones or the stone circles that vividly transport you to Carnac and the coast of Brittany. After their long journey, the prehistoric druids recalled their distant homes. The ancient Bonpo may, in some way, be connected with these menhirs. In any case, this discovery rounded out our search for traces of the great migrations.

Details of the costumes and arms of the Tibetans also give rise to significant comparisons. Let us take the ancient swords of the Tibetans and see whether there is any resemblance to some of the swords from Gothic burial grounds. Let us take fibulae (shoulder buckles) and compare them with those of the Alan and Gothic burial places in southern Russia and Europe: Before me is a fibula with a double-headed eagle of the exact same stylization as one found on the Kuban. Here is another Tibetan buckle from Derge, of ancient workmanship, with a lion at the foot of a mountain and with stylized flowers around. Take

the Scythian buckle found by Koslov that is of the same size, and you will be surprised to see the same concepts. Besides menhirs and cromlechs in the region of Shenza-Dzong, we also found ancient burial places in the Trans-Himalayas which recalled the Altai burial places and the graves of the southern steppes. It is a pity that excavations are not possible in Tibet, as the people claim that Buddha prohibited touching the depths of the earth.

In the same district of the Trans-Himalayas called Doring—Long Stone, apparently because of the ancient menhirs—we saw a woman's headgear, quite unusual for Tibet. It was exactly like the Slavonic kokoshnik, red as usual, adorned with turquoise and silver coins or ornamented with beads. Neither to the north nor to the south of this region did we again see such headgear. Apparently, some special tribal remnants have survived here. Their language does not differ from the other northern mixed dialects. In general, the Tibetan dialects are a problem, for besides the basic Lhasa dialect, every region retains its own dialect; and these are so different that the Tibetans of Lhasa at times cannot understand their own people.

There were two other interesting analogies. When I showed a Tibetan a unicorn from a coat of arms, he was not surprised but insisted that in Tibet there was and still exists near the region of K'am an antelope with one horn. Some Tibetans even volunteered to procure such an antelope for us should we stop in Tibet. The unicorn is also found on Chinese and Tibetan tankas. The British explorer Bryan Hodson has exported a specimen of a special antelope with one horn. And so the heraldic myth becomes reality near the Himalayas.

Another interesting object that we saw in different parts of Tibet is the sacred bead, the dzi or zi, of which two kinds exist. One is a Chinese imitation, the other is the ancient bead valued very highly in Tibet, sometimes as high as fifteen hundred

rupees each. Miraculous power is attributed to the dzi. We were told that, during the tilling of the fields, the beads jump out of the ground. People say that the dzi is a hardened dart of lightning or the excrement of a heavenly bird. The value of the dzi varies according to the number of signs on it. The bead looks like a piece of horn with some special signs on it. It is interesting that a similar bead was found, during the excavations in Taxila, among antiques of a period not later than the first century of our era. Thus, the age of the dzi is correctly estimated by the Tibetans. Perhaps they were ancient talismans or terraphim.

It should also not be forgotten that the Catholic missionary, Odorico de Pardenone, who visited Tibet in the fourteenth century, stated that Lhasa, or even the entire country, was called Gota. Let us remember the legendary kingdom of the Goths.

In order to conclude our analogies, let us recall, without drawing any conclusions, that the tribes of northern Tibet, called the Hors, remind one strongly of certain European types. There is nothing Chinese, Mongolian, or Hindu in them. Before you, somewhat modified, you see faces that could come from portraits of old French, Dutch, and Spanish artists.

The people of northern Tibet may be compared to the inhabitants of Lyons, the Basque Provinces, or Italy with their large, straight eyes, aquiline noses, characteristic wrinkles, thin lips, and long, black locks of hair.

Let us now glance at the art of Tibet. The ancient art is now beginning to be appreciated and its true value to be recognized. I would predict, even further, that the appreciation of ancient Tibetan art will increase still more.

The paintings, tankas, or frescoes of an earlier period than the nineteenth century afford one the greatest delight. We do not insist that there is a special Tibetan style. Of course, in the

art of Tibet we always recognize a blending with old China, India, or Nepal, as the first image of Buddha came to Tibet in the sixth century from China and Nepal. The Chinese and Hindu sources were so exquisite, however, that the blending of them results in a highly artistic composite.

But, in the nineteenth century the art became mechanical with the stereotyped weak repetition of the fine old forms. Therefore, in judging Tibetan art, we would say that at present, during the transition, there is no proper art and creativeness in Tibet. The Tibetans themselves understand very well that their old workmanship is superior in every respect to what is produced at present. But even in this conclusion, the verdict is not of hopelessness.

The experienced eye may observe that new values are entering life, though reticently. Let us hope that the present transition of Tibet will resolve itself in a rational approach to true values.

The enlightened lamas will find means to raise the religion once again to the true commandments of Buddha. The people will find application for their abilities, for the Tibetan people are naturally very able. The creative power of Tibet will eschew all mechanical repetitions and the lotus of knowledge and beauty will blossom and illumine the country.

Architecture in Tibet also suggests many unusual possibilities: the old Tibetan strongholds, for instance, beginning with the principal building of Tibet—the seventeen-story Potala. Are similar structures not adaptable to improvement, and do they not approach our skyscrapers?

At present in Lhasa, electric light has been prohibited on the streets; moving pictures are prohibited; sewing machines are prohibited; European footwear is prohibited. Again, Tibet has forbidden its laymen to cut their hair. If the higher military

officials cut their hair, they are demoted. The people have again been ordered to wear long robes (most inconvenient for work) as well as Tibetan-Chinese footwear.

The *Statesman* of 17 February 1929 states in connection with the proposed fourth Mount Everest expedition:

> If it was difficult to obtain permission from Tibet previously, then at present it is completely impossible. Further, the inhabitants of the Arun valley, who have made good money on foreigners, are against the latter entering the valley for a fourth time. People say that when the expedition of 1924 returned to India, the Dalai Lama fell ill for a day. Careful investigations were made all over Tibet to find out where the lama-monks had broken their vow, and it was found that a monk of the Arun valley had eaten fish. To justify his deed, which had endangered the life of the Dalai Lama, the monk could say only that he had become terribly excited on seeing foreigners near the monastery.

I remember a story about three hens. In our caravan we had three hens which, despite their daily travels in a basket on a camel's back, continued to lay regularly. After our detention in Nagchu, we had nothing to feed them and we gave them to the Tibetan major. The disappearance of the hens from our camp was at once reported to the governor of Nagchu, and an entire correspondence ensued about the hens having been eaten by foreigners. The major had to sign a written statement that the hens were still alive. It is strange that one may not eat fish or birds, nor kill a mad dog, nor a dangerous condor, but one may kill a yak or a sheep, not only for the use of laymen, but even for lamas to eat.

We think that it was not the fish eaten by the lama that caused the illness of the Dalai Lama, but more probably the unspeakable dirt with which some monasteries are "decorated."

Why must lamas have black, shiny faces and arms? We were shocked to see these coal-black people with so open an aversion to water. I can well imagine how difficult it must be for the Tashi Lama and other enlightened lamas to influence the black, self-satisfied masses. For it is pure ignorance that gives birth to self-satisfaction and self-content.

All these evidences of dirt, untruth, and hypocrisy were not bequeathed by the Blessed Buddha! The Teaching of Buddha stipulates, first of all, self-improvement and progress, whereas the prohibitions that I have mentioned indicate, first of all, a stupid adoration of the old. But in such retrogression, one may easily return to the incoherence of our forefathers. The past is good so long as it does not impede the future. But what if the beauty of the past has been allowed to die and future progress is prohibited?

Tibet has presumed its spiritual supremacy over its neighbors. The Tibetans look down on Sikkimese, Ladakhis, and Kalmuks and call the Mongols their bondsmen. Yet all these people are growing in consciousness, while Tibet tries forcibly to arrest the steps of evolution. And yet one notes how the Tibetan people themselves are attracted to everything that enhances comfort and lightens work.

I make these observations with no desire to belittle the Tibetans. I have often had occasion to note the keenness, flexibility, and industry of these people. We had several Tibetans in our house and were quite satisfied with them, parting as friends. Mrs. Roerich had a Tibetan aya who worked very well and with great dignity in our household. Knowing these fine sides of the Tibetan nature, one can only regret that these people do not receive sufficient guidance and that those who could guide them are not permitted to do so. The heart of Tibet is beating and the temporary paralysis of some of its organs

will pass. In the ancient history of Tibet we find glorious, though short, pages. Let us remember that Tibetan conquerors reached Kashgar and went beyond Kukunor. Let us remember that the fifth Dalai Lama bestowed flourishing prosperity on his country and crowned it with the Potala, which even now is the only significant building of Tibet. Let us not forget that a whole succession of Tashi Lamas left behind them monuments of enlightenment and that it is the Tashi Lamas who are united with the conception of Shambhala.

The temporary obscurity will disappear, and those who once knew how to build eagles' nests on the summits will again remember the glorious days of bygone Tibet and will revive them in the present.

The last pass is Sepo La. It is the easiest of all. We pass a turquoise blue lake—the source of the Lachen River. The torrent begins as a diminutive stream; and, after a journey of two days, it begins to roar and grows so powerful that one can no longer cross without a bridge. We sense the fragrance of the healing Balu and the first stubby cedars. Once again we see rhododendron before us. We are in Sikkim.

Again, files of bronze, half-naked Sikkimese with garlands on their heads carry baskets full of tangerines on their backs. The noisy monkeys whistle in the trees. Blue butterflies, large as birds, fly ahead of us. Everything is a rich, varied green. From above, crowned by rainbow clouds, fall cascades.

Near the Tishta River, two leopards appear on the road. They look at us peacefully and then, with their soft step, disappear in the jungle.

The Himalayas block our view of Tibet. Where else is there such brilliance, such spiritual plenty, if not among these precious snows! Nowhere else does there exist such descriptive language as in Sikkim; to every word the conception of hero is added: men-heroes, women-heroes, hero-rocks, hero-trees, hero-waterfalls, hero-eagles.

Not only are spiritual summits concentrated in the Himalayas, but physical wealth as well gives to this land of snows its great fame. Throughout the world the legend of the Fire-blossom is known. In China, Mongolia, Siberia, Serbia, Norway, Brittany, one may hear of the miraculous Fire-blossom. And where does the source of this legend lead one? To the Himalayas themselves!

In the Himalayas grows a special species of black aconite. The natives say they gather it by night when it glows and can thus be distinguished from other species of aconite. Truly, the Fire-blossom grows in the Himalayas!

The Hindu sings: "I can speak of the grandeur of the Creator when I know the incomparable Beauty of the Himalayas!"

If you ask me which of the many different impressions especially inspired me, I will answer without hesitating: Shambhala!

PART II

SHAMBHALA

If I pronounce for you the most sacred word of Asia, Shamb-
hala, you will be silent. If I pronounce the same name in Sanskrit,
Kalapa, you will be silent. Even if I tell you the name of the
mighty Ruler of Shambhala, Rigden Djapo, this thundering
name of Asia will not move you. But you are not at fault. All
the indications about Shambhala are scattered in literature,
and not one book has as yet been written in any of the Western
languages about this stronghold of Asia. But if you wish to be
understood in Asia and to approach as a welcome guest, you
must meet your host with the most sacred word. You must
show that these conceptions are not mere empty sounds for
you but that you value them and can coordinate them with the
highest concepts of evolution.

Baradiin, the Buryat scholar, in his latest book on the
monasteries of Mongolia and Tibet, states that, among other
things, monasteries in honor of Shambhala were founded re-
cently in China and Mongolia, and that in some of the existing
monasteries special *datsans* of Shambhala have been insti-
tuted.

To the casual reader this information may no doubt sound
metaphysical and abstract or unimportant. To the skeptical
observer such news, drowned in the day's political and com-
mercial speculations, may seem but another seed of supersti-
tion, devoid of reality.

But the attentive observer who has penetrated the depths

of Asia will feel quite otherwise. For him, this news will be full of importance, full of significance for the future. With this information, the person familiar with the sources of Asia will feel again how vital to Asia are all the so-called prophecies and legends emanating from the most ancient origins. The oldest Vedas, the more recent Puranas, and an entire literature of most varied sources affirm the extraordinary meaning for Asia of the mysterious word, Shambhala.

Both in the large populous centers of Asia, where sacred conceptions are pronounced with a cautious glance, and in the limitless deserts of the Mongolian Gobi, the word Shambhala, or the mysterious Kalapa of the Hindus, sounds like the most realistic symbol of the great Future. In tales about Shambhala, in legends, songs, and folklore, is contained what is perhaps the most important message of the East. He who as yet knows nothing of the vital importance of Shambhala cannot state that he has studied the East and knows contemporary Asia.

Before speaking of Shambhala proper, let us remember the Messianic conceptions which are to be found among the most varied peoples of Asia and which unite them into one great future expectation.

The yearning of Palestine toward a Messiah is well known, as is the anticipation of a great Avatar near the Bridge of the Worlds. People know of the White Horse and the Fiery Comet-like Sword and the radiant advent of the Great Rider above the skies. The learned rabbis and Kabalists throughout Palestine, Syria, Persia, and the whole of Iran relate remarkable things on this subject.

The Moslems of Persia, Arabia, and Chinese Turkestan reverently preserve the legend of Muntazar, who will soon lay the foundation of a New Era. It is true that when you speak to the Mullahs of Muntazar, they will sharply deny it at first; but

if you insist persistently and show sufficient knowledge; they will gradually cease their denials and often even add many important details. And if you still persist and tell them that in Isphahan they have already saddled the white horse that is to carry the Great Coming One, the Mullahs will look at each other and add that in Mecca a Great Tomb is already prepared for the Prophet of the Truth.

The most learned Japanese, the great scholars, speak highly of the awaited Avatar; and the learned Brahmins, taking their information from the Vishnu Puranas and the Devi Puranas, quote beautiful lines about the Kalki Avatar coming on a white horse.

For the moment I shall not touch on any of the inner signs which have gathered round the conception of Shambhala.

To transmit a more realistic impression, I first want to relate how and where we came in contact with people who know and are devoted to the Great Conception of Asia. We already knew about Shambhala. We had already read the translation by Professor Grünwedel of the Tibetan manuscript, *Road to Shambhala,* written by the Third Tashi Lama, one of the most esteemed high priests of Tibet.

First, then, let us examine the milestones which we passed during our five years of travel:

In the Temple of Ghum monastery, not far from the Nepalese frontier, instead of the usual central figure of Buddha, you see a huge image of the Buddha-Maitreya, the coming Saviour and Ruler of Humanity. This image is like the great image of Maitreya in Tashi-Lhunpo near Shigatse, seat of the spiritual ruler of Tibet, the Tashi Lama. The Lord Maitreya is seated on his throne; his legs are no longer crossed, as usual, but are already set on the ground. This is a sign that the time of His Coming is near and that the Ruler is already

preparing to descend from his throne. This monastery was built about twenty years ago by a learned Mongolian lama, who came from distant Mongolia to Tibet. Crossing the Himalayas and Sikkim, where the Red Hat sect of Padma Sambhava is the official religion, he came to erect this new monastery and to proclaim the approaching advent of the Lord Maitreya.

In 1924, a learned lama, the faithful disciple of the founder of the monastery who had shared with him the profound Teaching and many prophecies for the future, told us before the impressive image:

"Truly, the time of the great advent is nearing. According to our prophecies, the epoch of Shambhala has already begun. Rigden Djapo, the Ruler of Shambhala, is already preparing his unconquerable army for the last fight. All his assistants and officers are already incarnating.

"Have you seen the tanka-banner of the Ruler of Shambhala and his fight against all evil forces? When our Tashi Lama fled from Tibet recently, he took with him only a few banners, but among them were several about Shambhala. Many learned lamas fled from Tashi-Lhunpo and recently there arrived from Tibet a geshe (learned) painter, a gelong of Tashi-Lhunpo. He knows how to paint the tanka of Shambhala. There are several variations of this subject, but you should have the one with the battle in the foreground."

Shortly after, the lama-artist Lariva was seated on a rug in the white gallery of our home, outlining the complicated composition on the white surface of the specially prepared canvas. In the middle was the Mighty Ruler of Shambhala in the glory of His majestic abode. Below raged a terrific battle in which the enemies of the righteous Ruler were ruthlessly destroyed. In dedication, the banner was adorned by the following in-

scription: "To the Illustrious Rigden, King of Northern Shambhala."

It was touching to observe with what respect and veneration the lama-artist worked. When he pronounced the name of the Ruler of Shambhala, he clasped his hands as if in prayer.

At the time of our arrival in Sikkim, the Tashi Lama had fled from Tashi-Lhunpo to China. Everyone was startled by this unprecedented movement of the spiritual head of Tibet. The Lhasa government, in confusion, began searching everywhere, but rumors were already circulating that the Tashi Lama had passed through Calcutta in disguise.

Referring to this event, a lama said to us: "Verily, the old prophecies are fulfilled. The time of Shambhala has come. For centuries and centuries, it has been predicted that before the time of Shambhala, many wonderful events would occur; many terrible wars would take place; and Panchen Rinpoche would leave his abode in Tashi-Lhunpo in Tibet. Verily, the time of Shambhala has come. The great war has devastated countries; many thrones have perished; earthquakes have destroyed the old temples of Japan; and now our revered Ruler has left his country."

Following their spiritual ruler, one of the most esteemed high priests, Geshe Rinpoche from Chumbi, whom the Tibetans regard as an incarnation of Tsong-Kha-Pa, arrived from Tibet. With several faithful lamas and lama-artists, the high priest traveled through Sikkim, India, Nepal, and Ladakh, everywhere erecting images of the Blessed Maitreya and teaching about Shambhala.

When the high priest with his numerous attendants visited Talai-Pho-Brang, our home in Darjeeling, where the Dalai Lama once lived, he, first of all, noticed the image of Rigden Djapo, the Ruler of Shambhala, and said, "I see you know that the time of Shambhala has approached. The nearest path for

attainment now is only through Rigden Djapo. If you know the Teaching of Shambhala—you know the future."

During his successive visits to us, the high priest spoke more than once of Kalachakra, not only attributing to this teaching a religious meaning, but applying it to Life like a real Yoga.

One meets the teaching of Kalachakra for the first time in 1027 of our era, when it was spread by Atisha. This is the Yoga of utilizing the high energies. From ancient times, in a few monasteries—the more learned ones—special schools of Shambhala have been established. Tashi-Lhunpo was always the chief center of the vital Yoga because the Tashi Lamas have been the high protectors of Kalachakra and were closely linked with Shambhala. In Lhasa, Moruling is considered one of the most advanced monasteries practicing Kalachakra; this monastery has only about three hundred lamas. It is said that from time to time the most learned of these lamas go to a mysterious retreat in the Himalayas and some of them never return. In some other monasteries of Gelugpa, the Yellow Hat sect, the teaching of Kalachakra is also practiced. This is also the case at Kumbum, the birthplace of Tsong-Kha-Pa, and in the Chinese monastery of Wu-tai-Shan. The high priest of this monastery has written a remarkable book, *The Red Path to Shambhala,* which is not yet translated.

In Chumbi monastery a huge banner is preserved representing the spiritual battle of Rigden Djapo. In this composition one sees legions of faithful warriors from all parts of the world hastening to take part in the great conflict for spiritual victory.

When our attention is fixed on a subject, like a light which penetrates dark corners, more and more details emerge.

Not long ago, in the *Shanghai Times* and subsequently in

many other newspapers, an extensive article appeared, signed by Dr. Lao-Tsin, telling of his journey to the Valley of Shambhala. In a vital narrative, Dr. Lao-Tsin recounts many details of his difficult journey with a Nepalese Yogi through Mongolian deserts and harsh uplands to the valley, where he found an abode of numerous Yogis studying the High Wisdom. His description of the laboratories, temples, and also of the famous tower, are surprisingly analogous to the descriptions of the remarkable place in other sources. He tells of many scientific wonders and of complex experiments in willpower and telepathy conducted over very great distances. It was significant to see how many countries were interested in his information.

When we traveled through the Sikkim monasteries we met several learned lamas who, although of the Red Hat sect, more than once mentioned the great approaching era and many details of Shambhala.

A learned lama, pointing down the slopes of the mountain, said: "Down below, near the stream, is a remarkable cave, but the descent to it is very difficult. In Kandro Sampo, a cave not far from Tashi-ding beside a hot spring, dwelt Padma Sambhava himself. A certain giant planned to build a passage across Tibet in an attempt to penetrate into the Sacred Land. The Blessed Teacher rose up and, growing great in height, struck the bold adventurer. So the giant was destroyed. And now the image of Padma Sambhava is in the cave and behind it is a stone door. It is known that behind this door the Teacher hid secret mysteries for the future. But the dates for their revelation have not yet come."

Another lama said: "There is a legend taken from an ancient Tibetan book, wherein the future movements of the Dalai Lama and Tashi Lama are given in symbolic form; these have

already been fulfilled. There are described the special physical marks of Rulers, under whom the country will fall. But afterwards, right will prevail and then Someone of greatness will come. His coming is calculated in twelve years—which will be in 1936."

At dusk, a Gelong said of the Lord Maitreya: "For twelve years a man searched for Maitreya Buddha. Nowhere did he find Him, and, angered, he rejected his faith. As he continued on his way, he beheld a pilgrim who, with a horse hair, was sawing an iron rod, repeating to himself, 'Even if the whole of life is not enough, yet will I saw this through.' Confusion fell on the wanderer. 'What do my twelve years signify,' he asked, 'in the face of such persistence? I shall return to my search.'

"Thereupon, before the man appeared Maitreya Buddha Himself and said, 'Long have I been with thee, but thou didst not see me, didst repulse me and spit upon me. I shall perform a test. Go to the bazaar. I shall be upon thy shoulder.' The man went, aware that he carried the God. But the men around him shrunk from him, closing their noses and eyes. 'Wherefore do you shrink from me, people?' he asked. 'What a horror you have on your shoulders—an ill-smelling dog full of boils,' they replied.

"Again the people did not see Maitreya Buddha, for they beheld only what each was worthy of seeing."

People are sensitive here. Emotions and desires are transmitted so easily. Therefore, know clearly what you desire. Otherwise, instead of God, you shall behold the dog.

The old high priest of a monastery said: "Our temple is very old. For many years I used to stay in the temple each night, ending and beginning the day with prayers. One night, I was awakened. Before me I saw two women dressed in Tibetan garments. They bade me leave the temple at once and, taking me

by the arms, led me to the steps of the entrance, where they both disappeared. At the same moment the wall of the temple crashed down and the place where I had been sleeping was crushed to pieces. Thus, two blessed Taras saved my humble life. And in their solicitude for me, they assumed the appearance of Tibetan women in order not to frighten me with their sudden appearance at night. The time of Shambhala is coming and many wonderful signs will appear before the Great Advent."

The old priest knew of other wonderful things. Like the hermit Milarepa, he had heard inaudible voices. He had heard the flight of invisible birds and bees. On that very day, he had had a vision before dawn when many flames leaped up like a garland on the mountain slope. These fiery signs accompany the era of Shambhala. I repeat this as I heard it at the very scene of the vision. We must not wonder at these unfamiliar experiences. We must know things as they now exist in many countries.

From the following episode that we experienced, one may see how deeply the local sensitivity must be understood. Mrs. Roerich wanted an old image of Buddha. But this is not easy because old images are very rare and the owners have no intention of parting with them. We spoke about it only among ourselves. To our surprise, some days later a lama came to see us and with a bow took out a beautiful Tibetan image of Lord Buddha from his coat and presented it to Mrs. Roerich, saying, "Memsahib wanted to have an image of Buddha. The Blessed White Tara appeared to me in a dream and ordered me to give you this image of the Blessed One from my altar." In this way we received a long-desired image.

Another unforgettable incident occurred near Ghum Monastery. One day, about noon, four of us were driving along the mountain road. Suddenly, our driver slowed down. On the narrow road we saw a litter borne by four men in grey. In it was

seated a lama with long black hair and with a small black beard, which is quite unusual for lamas. On his head he wore a crown. His red and yellow vestment was sparkling clean. The litter passed close to us and the lama smilingly nodded several times. We continued on our way, retaining our impression of the unusual lama for a long time after. Later we tried to find him, but to our great astonishment, the local lamas informed us that, in the entire district, there was no such lama. They also told us that none but the Dalai Lama, the Tashi Lama, and the dead of high rank are carried by litter, and that the crown is used only in the temple. The lamas whispered, "Probably you saw a lama from Shambhala!"

One Tibetan lama, during his visit to the holy places of India, met on the train an old Hindu sadhu who did not understand Tibetan. By chance, the lama began to speak to him. Although the latter answered him in Hindustani, each understood the other. When the lama told us of this experience, he added: "Only in the time of Shambhala shall all languages be understood without previous study because we hear and understand not the outward sound, and we see not through the physical eye but through the third eye, which you see symbolized on the forehead of our images—this is the eye of Brahma, the eye of all-seeing knowledge. In the time of Shambhala, we will not need to rely only on our physical sight. We shall be able to avail ourselves of our great inner forces."

On the summits of Sikkim, the foothills of the Himalayas, among the blooming rhododendrons and the fragrant Balu— the healing plant—a lama who looked like a carved image from the middle ages told us, pointing towards the five summits of Kanchenjunga: "There is the entrance to the holy land of Shambhala. By passages through wonderful ice caves under the earth, a few deserving ones have, even in this life,

reached the holy place where all wisdom, all glory, all splendor are gathered."

Another lama of the Red Hat sect told us about wonderful Asaras, Hindu in appearance, with long hair and white attire, who often appear in the Himalayas, "wise men who know how to master the inner energies and to unite them with cosmic energies." According to this lama, the head of the Medical School in Lhasa, a learned old lama, knew such Asaras personally and was in touch with them.

The *Statesman*, the most accurate newspaper in India, published the following experience related by a British major:

> Once before sunrise, while camping in the Himalayas, the major went from his camp to the neighboring cliffs to see the majestic snow-capped outlines of the mountains. On the opposite side of the gorge rose a high rock. Great was his astonishment when, through the morning mist, he noticed on the rock the figure of a tall man, almost naked and with long black hair. The man was leaning on a tall bow, attentively watching something behind the rock. Then, apparently noticing something, the silent figure, with great strides leaped down the almost vertical slope. Amazed, the major returned to the camp and asked the servants about this strange apparition. To his surprise, they took it quite calmly and with reverence told him: "Sahib has seen one of the snowmen who guard the forbidden region."

We asked a lama about the snowmen and again the answer came in a surprisingly calm and affirmative way: "These snowmen are very rarely seen. They are the faithful guardians of the Himalayan regions where the secret Ashrams of the Mahatmas are hidden. Formerly, even in Sikkim we had several Ashrams of the Mahatmas. These wise Mahatmas of the Himalayas direct our lives through unceasing work and study. They master the highest powers. And, as perfectly ordinary

people, they appear in various places, here, beyond the ocean, and throughout Asia."

To our surprise, our friend mentioned a story, which we had already heard, of how one of the Mahatmas, for some pressing reason, undertook an urgent journey to Mongolia, remaining in the saddle about sixty hours.

One experiences a special emotion in these remote mountains on hearing the living words of what one has only read in the pages of distant books because the white surfaces of glaciers often conceal the physical traces of travelers. But a simple disinterested narrative carries great conviction.

Truly, many things which seem fantastic and fairy-like change when observed without prejudice in the very places where they occurred and become transmuted into a living force. And the majestic images of the Mahatmas no longer pass before our eyes as phantoms; they become great physical beings, true Masters of the Higher Knowledge and Power.

You may ask me why, in speaking of Shambhala, I mention the Great Mahatmas. Your question would be justified because, until now, these two great conceptions have been separated in literature due to lack of information. But after studying the writings about the Great Mahatmas and after learning of Shambhala here, it is highly significant to see the links between these two concepts and finally to understand how near they are to each other in reality.

In Hindu literature, in the Vishnu Puranas, you may find several indications which are understood equally by students of the Teaching of the Mahatmas and by the faithful devotees of the Teaching of Shambhala.

In the old scriptures there are inspiring indications about a new predestined era, about great avatars coming to save humanity, about the sacred city Kalapa, about the efforts of the Arhats in every century to arouse the slumbering spirit of humanity. We see the same indications in the Teachings of the Great Mahatmas and in the scriptures and sagas concerning Shambhala. In Sanskrit, in Hindustani, in Chinese, in Turkish, in the Kalmuk, Mongolian, and Tibetan languages, and in many minor Asiatic tongues the same ideas, the same indications concerning the Future are expressed.

One might perhaps attribute this to the usual Messianic idea. One might even believe that in the ancient period of the Nestorians and Manicheans, scattered through Asia for several centuries, the concepts of a second coming were transformed into this teaching of the future. Perhaps it seems so from afar. But studying the subject at its source among the various nationalities who are separated by immense deserts and many thousands of miles, you see that these teachings are far more ancient than the Messianic idea and they deal not only with a personification, but specifically with the concept of a New Era identified with gigantic cosmic energies.

In the basic teaching of Buddha one may already find some suggestions about future attainments of humanity. Beneath the symbol of an iron serpent encircling the earth, you see the symbols of railways, transporting and laboring for humanity. From the symbol of flying iron birds, you understand aircraft. In indications about life on the stars and in allusions to the various states of human existence, you may recognize the same theories that science is gradually confirming—of life on the planets, of the discoveries of the astral world, all of which, until recently, were subjects for ridicule.

It is truly strange to recognize links between the oldest

Vedic traditions and the new conceptions of Einstein. But we must not forget that even Buddha came to clarify the declining and corrupted forms of culture and taught about the subtle Cosmic Energies. Only recently in the districts of Karachi and Lahore, ruins of ancient cities five thousand to six thousand years old were discovered, showing the advanced culture of ancient India. This culture reminds one of the culture of the Sumerians and Elams. Many cylinders like those of Babylon were found in these ruins, disclosing a new literature when deciphered. Without these comparatively recent discoveries, India's medieval glory would seem to have ended several centuries before our era. The words of the ancient legends and scriptures came as if from unknown space; but these discoveries have now given a basis of reality to this ancient knowledge. Guided by these wayside signposts, we may begin to think about the indications of Plato, about the destruction of Poseidon, the last stronghold of Atlantis.

We see then, that many symbols and signs are, in fact, far more ancient than the age attributed to them by scientists of the last century.

Many concepts which would seem to be completely unrelated reveal their close connection upon attentive and unprejudiced study.

For instance, what connection has Buddhism with early Christianity? Yet even Origen refers to the Buddhists and Druids of Britain. The missionaries of King Ashoka might easily have gone to Britain and come into contact with the old sun cult of the Druids. The serpent lore of Scotland must be considered parallel with the dragon lore of China as well as with the serpent lore of India. The great sign of the cross is universal and traverses all ages, through Egypt, through the swastika of untold antiquity.

One listens with special emotion to the old prophecies and legends which represent to these learned lamas and Brahmins the real wisdom and the Teaching of Life.

In order to convey a sense of this atmosphere, I shall give extracts from the Vishnu Puranas and translations from Tibetan Prophecies.

Among the commandments of Tsong-Kha-Pa there is one which indicates that each century the Arhats attempt to enlighten the world. Up to the present, none of these attempts has been successful. It is said that until Panchen Rinpoche (the Tashi Lama) consents to be reborn in the land of the pelings (Westerners) and, as spiritual conqueror, to destroy the age-old errors and ignorance, it will be of little use to try to uproot the misconceptions of the pelings.

In 1924, Alexandra David-Neel, who had been in Tibet, wrote several articles about the traditions of Gesar Khan, whose legendary personality stands alongside Rigden Djapo, Ruler of Shambhala, and has many links with him.

She brought back the ancient prophecies about Gesar Khan, of how he is gathering his faithful warriors and is preparing to purge Lhasa of its nefarious elements.

In her article "The Coming Northern Hero," Mrs. David-Neel says: "Gesar Khan is a hero whose new incarnation will take place in Northern Shambhala. There he will unite his co-workers and leaders who have followed him in his previous life. They too will incarnate in Shambhala, whereto they will be attracted by the mysterious power of their Ruler or by the mysterious voices which are heard only by the initiate." The Ruler Gesar Khan is coming with an invincible army to destroy the nefarious elements of Lhasa and to establish justice and prosperity everywhere.

In Tibet we had occasion to convince ourselves of this

legend. We were told of Gesar Khan's palace in Kham, where the swords of his army are collected, serving as beams for his palace. The arrow is the sign of Gesar Khan. His arrows are lightning and the arrow tips found in fields are considered to be crystallized thunderbolts. War is declared by the shooting of an arrow. The order for mobilization is, as we have seen, wrapped around an arrow. Gesar Khan is armed with arrows of thunder and the predestined army will soon be ready to come out of the sacred land for the salvation of mankind. He who can read the sacred runes will understand to what new epoch of spiritual triumph these symbols refer.

Let us recall also the Tibetan prophecies about Shambhala and Maitreya:

PROPHECIES OF SHAMBHALA AND MAITREYA

The Treasure is returning from the West. On the Mountains the fires of Jubilation are kindled.

Look towards the road—there walk the bearers of the Stone.

Upon the Shrine are the signs of Maitreya. From the Sacred Kingdom is given the date when the carpet of expectation may be spread. By the signs of the seven stars shall the Gates be opened.

By Fire shall I manifest My Messengers.

Gather the prophecies of your happiness.

Thus are the prophecies of the ancestors fulfilled and the writings of the wise ones. Gather your understanding to hail the Predestined.

When in the fifth Year the heralds of the warriors of Northern Shambhala shall appear, gather understanding to meet them. And receive the New Glory! I shall manifest My Sign of Lightning.

THE COMMAND OF GESAR KHAN

I have many treasures but only upon the appointed day may I bestow them upon My People. When the legions of Northern Shambhala shall bring the Spear of Salvation, then will I uncover the depths of the mountain and you shall divide My Treasures among the warriors and yourselves equally, and live in justice.

The time shall soon come for that command of Mine to cross all deserts. When My gold was scattered by the winds, I ordained the day when the people of Northern Shambhala would come to gather My possessions. Then shall My people prepare their sacks for the treasures, and to each will I give a just share.

One may find sands of gold. One may find precious gems. But the true wealth shall come only with the People of Northern Shambhala. When the time is come to send them forth.

Thus is it ordained.

It is predicted that the manifestations of Maitreya shall come after the wars. But the final war shall be for the cause of the

True Teaching. Whoever rises up against Shambhala shall be stricken in all his works. And the waves shall wash away his dwelling. And even a dog shall not answer to his call. Not clouds but lightning shall he see on the final night.

And the fiery messenger shall rise up on pillars of Light. The teaching indicates that each warrior of Shambhala shall be named the Invincible.

The Lord Himself hastens. And His Banner is already above the mountains.

Your Pastures shall reach the Promised Land.

When you tend your flocks, do you not hear the voices of the stones? These are the toilers of Maitreya who make ready for you the treasures.

When the wind murmurs through the reeds, do you understand that these are the arrows of Maitreya, flying in protection?

When lightning illumines your camps, do you know that this is the light of the desired Maitreya?

To whom shall be entrusted the watch upon the first night? To you. To whom shall My envoys be dispatched? To you. Who shall meet them? You.

From the West, from the mountains, shall come My People. Who shall receive and safeguard them? You. Beseech the Tara to rest with you. Resolve to cleanse your hearts until My Coming. Each one who hears My desires shall cover his fur cap with a fiery cover and shall entwine the headstrap of his horse with a fiery cord.

Look sharply upon the rings of the coming ones. Where

My chalice is—there is your salvation. Upon the mountain, fires are kindled.

The New Year is coming. Whoever shall out-slumber it shall not again awaken. Northern Shambhala is come!

We know not fear. We know not depression. Dukkar, the many-eyed and many-armed, sends us pure thoughts. Ponder with pure thoughts. Ponder with thoughts of light.

One two three! I see three peoples.

One two three! I see three books. The first is of the Blessed One Himself. The second is given by Asvagosha. The third is given by Tsong-Kha-Pa.

One two three! I see three books of the coming of Maitreya. The first is written in the West. The second is written in the East. The third will be written in the North.

One two three! I see three manifestations. The first is with the sword. The second is with the law. The third is with the light.

One two three! I see three horses. The first is black. The second is red. The third is white.

One two three! I see three ships. The first is on the waters. The second is under the waters. The third is above the earth.

One two three! I see three eagles. The first is perched upon the stone. The second is pecking at his prey. The third is flying towards the sun.

One two three! I see the seekers of light. Red ray! Blue ray! Ray of silver-white!

I affirm that the Teaching issued from Bodh-Gaya shall return there. When the procession carrying the Image of Shambhala shall pass through the lands of Buddha and return to the first source, then the time shall arrive of the pronouncing of the sacred word of Shambhala.

Then shall one receive merit from the pronouncing of this name.

Then shall the thought of Shambhala provide sustenance. Then shall affirmation of Shambhala become the beginning of all works and gratitude to Shambhala, their end. And great and small shall be filled with understanding of the Teaching.

Sacred Shambhala is pictured amidst swords and spears, in impenetrable armor.

Solemnly I affirm: Shambhala the invincible!

The circle of the bearing of the Image is complete. The Image is borne through the places of Buddha, through the sites of Maitreya. "Kalagiya" is pronounced. The banner of the Image unfurls.

What has been pronounced is as true as that under the Stone of Ghum lies the Prophecy of Sacred Shambhala.

The Banner of Shambhala shall encircle the central lands of the Blessed One. Those who accept Him shall rejoice. And those who deny Him shall tremble.

The Tashi Lama shall ask the Great Dalai Lama, "What is predestined for the last Dalai Lama?"

He who denies shall be given over to justice and shall be forgotten. And the warriors shall march under the banner of Maitreya. And the city of Lhasa shall be dark and deserted.

Those rising against Shambhala shall be cast down. To those in darkness, the Banner of Maitreya shall flow like blood over the lands of the new world. To those who have understood, like a fiery sun.

The Tashi Lama shall find the Great Dalai Lama and the Great Dalai Lama shall address him thus: "I will send thee the worthiest sign of my lightning. Go, overthrow Tibet. The ring shall protect thee."

Let us also remember some Hindu traditions:

The Kalki Purana thus mentions the Kalki Avatar that is yet to come:

"At your request I shall be born in the abode of Shambhala. I shall again place the two rulers, Maru and Devapi, on earth. I shall create Satya-Yuga and restore the Dharma to its former condition and after destroying the serpent Kali, I shall return to my own abode."

Vishnu Purana continues:

"Devapi and Maru . . . dwelling in Kalapa and endowed with great yogic powers, guided by Vasudeva, at the end of Kali will establish Varna and Ashrama Dharma as before."

Shrimad Bhagavata in book VI says:

"Unnoticed, these Maharishis and other great Sidhas are voluntarily moving about on the face of the earth for the purpose of affording spiritual enlightenment to those who follow worldly attractions; thus do I."

Shankaracharya, in his Viveka Chudamani says:

"Those Great Ones, who have attained peace and have Themselves finished swimming across the fearful ocean of births and deaths, exist and move for the good of the people, as does the Spring. Unselfishly they liberate mankind."

The Vishnu Purana speaks of the end of Kali Yuga, when barbarians will be masters of the banks of the Indus: "There will be temporal monarchs, reigning over the earth, kings of

churlish spirit, of violent temper, addicted to falsehood and cruelty. They will inflict death on women and children, and they will seize the property of their subjects their lives will be short, their desires insatiable. People of various countries will intermingle with them. Wealth will decrease until the world becomes wholly demoralized.

"Property alone will confer rank; wealth will be the only source of devotion. Passion will be the sole bond between sexes. Perjury will be the only means of success in litigation. Women will be objects merely of sensual gratification. A rich man will be reputed pure. Fine attire will be the mark of dignity.

"Thus in the Kali age will decay continue. Then at the end of the Kali Yuga, the Kalki Avatar will descend upon the earth. He will reestablish righteousness. When the Sun and Moon and Tishya and the planet Jupiter are in one mansion, the Satya Age will return—the white age!"

Thus say the Agni Puranas:

"At the end of Kali Yuga there will be mixed castes. Merciless robbers will flourish. Under cover of religion, men will preach irreligion. And the Mlechhas, in the guise of kings, will devour men. Armed with a coat of mail and with weapons, Vishnuyasha's son Kalki, will annihilate the Mlechhas, establish order and dignity, and lead the people on the path of truth. Then, having renounced the form of Kalki, Hari will return to heaven.

"Thereupon Kritayuga will exist as before."

With a pilgrim's staff let us pass through Benares, where it is said that Maitreya will be born. Let us cross the old road to

Kadarnath, leading to the great Kailas, abode of mighty her-
mits and the milestone to Shambhala. Let us pass Lahore, with
its ancient nearby cities. Let us go to Kashmir and the throne
of Solomon on the summit of the mountain. There, in the land
of Ashoka's son, stood a Buddhist temple, destroyed by the
Hindus. In these ancient places once again is heard the name
of Maitreya.

Reaching the Ladakh border at Dras, besides old neolithic
designs, you may see the first image of Maitreya on the rocks.
Thus again, both the signs of the future—the Great Rider, the
Kalki Avatar of India, and the Maitreya predestined by Bud-
dhism—stand on the same road, blessing the pilgrims.

In ancient Maulbek, where many ruined monasteries re-
call the beautiful past, we were greeted on a most ancient
caravan road by a majestic image of Maitreya, probably carved
by an Indian hand and bearing on the back a Chinese inscrip-
tion. Is it not the same significant image that Fa-hsien, the
renowned Chinese traveler, so reverently describes in his
memoirs?

Even in Lamayuru, the old citadel of the Bonpo, this im-
penetrable half-Shaman religion, we found to our great surprise
an image of Maitreya. It seemed strange that a Bonpo temple
that rejects even Buddha should be concerned with Maitreya,
the Lord of the Future, predestined by Buddha. And yet this
call of the future penetrates places hostile even to Buddha
Himself.

In Saspul, a more ancient image of Maitreya exists, prob-
ably from the sixth century. An old lama, showing us this relic,
whispered to us of the approaching New Era. In this small
village with its many ruins of fortresses and temples dotting
the summit of the mountains, it was strange to hear about a
brilliant future. But this devotion to the future lends to these

isolated places not only a sense of the past, but the sense that they serve as milestones for achievements already predestined. If you show the old lama that you comprehend his language, not only literally but in its inner meaning, he will give you many remarkable indications. If you show him prophecies you received in India or Sikkim, mark with what keen interest he will ask you for permission to copy them. You may be sure he will not keep them for himself alone. Traveling lamas will carry these signs of regeneration to other isolated places.

Like a stronghold, high on the mountains, is one of the oldest monasteries, the Spithug monastery.

The high lama of this monastery was doubtful as to how to greet us or in what way to address us so that the first moments of our visit were somewhat delicate. But when we spoke of the concept of Shambhala, the front door was opened wide. We were invited into the picturesque room of the Incarnate Lama, surprisingly clean and inviting. Instead of a superficial conversation, we were at once asked how we knew of Shambhala; again many new details were told us and we saw that our host really regretted it when the time for our leave-taking came. "Someone from the West—and with knowledge of Shambhala! This is a sign of the New Era!" he exclaimed.

In Leh, the capital of Ladakh, especially, many memories of Gesar Khan and Shambhala are collected. Ladakh is regarded as the birthplace of Gesar Khan. The Maharajah of Ladakh is said to be a descendant of Gesar Khan. Many beautiful and romantic legends and songs dedicated to the great hero Gesar Khan and his wife Bruguma are related and sung in Ladakh. Here, high on the rocks, you may see a white door leading to the castles of Gesar Khan. Here, also, on a rock, is the image of a huge lion, connected with the same hero. On the

roads, several images of Maitreya may be seen. In Leh, near the temple of Buddha and of Dukkar, the Mother of the World, there is a special temple, finely decorated, dedicated to Maitreya. In the silent dusk of the temple you may distinguish on the beautifully painted walls the figures of Bodhisattvas, and in the two-story-high center, ready to descend from His throne, is the image of the Lord Maitreya. This temple is decorated with special veneration—the same veneration you feel when lamas come to your home to see the images of the Lord Maitreya and Shambhala.

One of our Western friends, unfamiliar with Buddhist matters, on observing the tanka of Shambhala, remarked that it seemed like the usual Tibetan banner. I asked him where and how often he had seen the same subject. Whereupon he naïvely admitted, "Well, perhaps not this identical one, but similar, with some Buddhas."

When one realizes the great subtlety of Eastern symbology and Buddhist iconography, it is strange to hear such superficial remarks about "some Buddhas." One may imagine the impression that such a gentleman of "some Buddhas" makes in an Eastern temple, when he begins to speak so lightly of such revered images. For some, everyone who sits cross-legged is a Buddha. It is through such ignorance that deep misunderstandings are created.

One educated Buddhist told us how he saved three Germans. They entered the temple smoking. Immediately, the crowd, peaceful until that moment, became furious and threatened bloodshed.

Not only should we not violate the feelings of people of different religions, but we should feel that the study of the subject in itself expands our outlook on life and gives us the real joy of knowledge.

Let us remember some Ladakhi songs on religious subjects.

Just before approaching the severe Sasser and Karakorum passes, we saw, for the last time, the image of Lord Maitreya in the frontier monastery of Sandoling. This monastery is renowned because there is a rock behind the monastery on which the rays of the setting sun project wonderful images. This is an old monastery, somewhat deteriorated externally. It was, therefore, all the more surprising to find absolutely new images of the Lord Maitreya, Shambhala, and Dukkar there. Looking at them, we should remember where modern creative thought is directed.

During many days of travel through no-man's-land, we naturally expected to find no milestones, no trace of a religious life. But facing the glaciers, we were reminded several times of the great names of the Future.

In the late evening, just before we crossed rocky Kurul Davan, an unexpected guest visited us, an old grey-bearded Moslem. Surrounded by huge rocks before the tent, in the moonlight, we spoke about the Koran and Mahomet (Muhammad). He told us how Mahomet venerated womanhood. Then he spoke about the manuscripts and legends of Issa (Jesus), the best of human sons. He told us how Moslems are eager to obtain, at any cost, everything concerning Issa.

Then we spoke of Muntazar, the Moslem symbol corresponding to the Kalki Avatar of the Hindus and to the Maitreya of the Buddhists. Our unexpected friend became enthusiastic. And the name of Maitreya was uttered with the same veneration as that of Muntazar. In his hopes, one felt future world unity, future joy, and understanding.

After crossing four snow-covered passes when we were already in the desert itself, we again saw a picture of the future.

In a spot surrounded by sharp, cragged rocks, three caravans had stopped for the night. At sunset, I witnessed a unique episode. On one of the stones a colorful Tibetan banner had been placed. Several people sat before it in reverent silence. A lama in red robes and a yellow cap was pointing something out to them on this painting with a stick and rhythmically chanting a descriptive prayer. Approaching, we saw the familiar tanka of Shambhala. The lama was chanting about the innumerable treasures of the King of Shambhala and about his miraculous ring bestowed on him by the Highest Powers. Designating with his pointer the battle of Rigden Djapo, the lama related how all evil beings shall perish mercilessly before the righteous force of the Ruler.

The campfires glowed—fireflies of the desert! From many countries, people gathered round one fire. Ten fingers were raised in awe as they related ecstatically how Blessed Rigden Djapo reveals Himself to give commands to His messengers— how on the black rock of Ladakh the mighty Ruler appears; and, from all directions, the mounted messengers with deep obeisance approach to listen; how at full speed they hasten to fulfill what is ordained by His great wisdom.

In Ladakh, we encountered for the first time a remarkable custom practiced by the lamas. During storms they ascend a mountain peak and, in prayer, cast to the wind tiny images of horses. These are sent to help travelers in distress. This custom brings to mind the legend of the North Dvina River that tells how St. Procopius the Righteous, sitting on the high banks of the mighty river, prayed for unknown travelers. Such signs of all-embracing human love!

Descending the mountains to the sands of Taklamakan, where you meet only Moslems, Sarts, and Chinese, and where you see the mosques and Chinese temples of Khotan, you would not expect to see anything about Shambhala. And yet, that is where we again came upon valuable information. Not far from Khotan are many ruins of old Buddhist temples and stupas. One of these stupas is identified with the legend: That in the time of Shambhala, a mysterious light will shine from it. It is said that this light has already been seen.

Many Kalmuks from Karashahr visit this place in worship. It is also said that the Lord Buddha passed through these places during his journey to the far north, to the Altai.

During our stay in Yarkend, Kashgar, and Kuchar, the people told us that in Kashgar there lived a holy man who at sunrise heard the cocks crow in the distant holy land which was six months' journey away.

Between Maral Bashi and Kuchar, our stableman Suleiman, pointing at a mountain to the southeast, said: "There behind that mountain live holy men. They have departed from the world in order to save humanity through their wisdom. Many have tried to reach their land, but few have ever reached it. They know that one must go beyond that mountain. But as soon as they have crossed the ridge, they lose their way."

It is easy to see that these legends refer to Shambhala and that even the geographical indications in them point in the same direction as the Shambhala of all Nations.

After passing through the Moslem cities and deserted cave-temples of the old Tokhar districts, we reached Karashahr, where Buddhism flourishes even now.

Karashahr is not only a stronghold of the Karashahr Kalmuks, but also the last resting place of the Chalice of Buddha, as cited by the historians. The Chalice of the Blessed One was brought here from Peshawar and disappeared here. It is said, "The Chalice of Buddha will be found again when the time of Shambhala approaches."

Purushapura, or Peshawar, was for many years the City of the Chalice of Buddha. After the death of the Teacher, the Chalice was brought to Peshawar, where it long remained the object of deep reverence. About 400 B.C., during the time of the Chinese traveler Fa-hsien, the Chalice was still at Peshawar, in a monastery especially built for it. It was of many colors, with black predominating, and the outlines of the four chalices that composed it were clearly visible.

In about 630 A.D., during the time of Hsuan-tsang, another Chinese traveler, the Chalice was no longer at Peshawar. It was already in Persia or in Karashahr.

In the East we cannot disregard the concept of a Chalice.

The Chalice of Buddha was miraculous and inexhaustible—a true Chalice of Life.

Let us remember the chalice of Amritha and the struggle for its possession, as related so poetically in the Mahabharata. Indra takes the chalice of the King of the Nagas and carries it to heaven.

According to Persian traditions, when Jemshid began to excavate the foundation for the city of Istaker, a miraculous Chalice, Jami-Jemshid, was found. The chalice was made of turquoise and was filled with the precious nectar of Life.

The legends from the Solovetz monastery, telling of the personalities of the Old Testament, mention the chalice of King Solomon:

"Great is the Chalice of Solomon, fashioned from pre-

cious stone. On the Chalice are inscribed three verses in Sumerian characters and no one can explain them."

The Moslems in Khandakhar have their own sacred chalice.

In Kharran there is also a sacred chalice, Faa-Faga: Those who take part in the mysteries drink from it. On the seventh day they announce, "O Teacher, may the inaudible be manifest!"

In the ceremonies of Vedism, Buddhism, and Mazdaism, the sacred Chalice of Life symbol is utilized everywhere.

A Jataka tells of the origin of the Chalice of Buddha:

"Then from the four lands came four guardians of the world who offered chalices made of sapphire. But Buddha refused them. Again they offered four chalices made of black stone (muggavanna) and he, full of compassion for the four wise men, accepted the four chalices. He placed one inside the other and ordained, 'Let there be one!' And the edges of the four chalices became visible as outlines. All the Chalices formed one. The Buddha accepted food in the newly formed Chalice and, having partaken of the food, he offered thanks."

Lalita Vistara, describing the sacraments of the Chalice of Buddha, attributes to the Blessed One the following significant address to the Kings who brought the chalices:

"Pay your respects to Buddha in the name of the Chalice, and the Chalice shall be to you as a vessel of knowledge.

"If you offer the Chalice to your peers, you will not remain, either in memory or in judgment.

"But he who offers the Chalice to Buddha will not be forgotten either in memory or wisdom."

This Chalice—the Ark of Life, the Chalice of Salvation—must be discovered soon again.

This they know in the deserts.

In Karashahr we met the Toin Lama, the Chief Prince of the Karashahr Kalmuks. It is said of him that he is a reincarnation of the famous Sanchen Lama of Shigatse, chief minister of the Tashi Lama. Sanchen Lama was tortured to death by the Lhasa government, which accused him of treason for his relations with the well-known traveler Chandra Das. People have not forgotten that the old Sanchen Lama had predicted his own fate and even ordered a painting to be made of the lake in which he was afterwards drowned. He also predicted that he would reincarnate soon in the country of the Kalmuks, and on the knee of the Toin Lama can be seen the mark that is characteristic of the Sanchen Lama.

With great astonishment, the Toin Lama listened to us speak about Shambhala. "Truly," he said, "the great era has dawned if you come from the West and you possess the greatest knowledge! We all are ready to sacrifice all our possessions, everything that may be of use to Shambhala. All riders will be mounted when the Blessed Rigden Djapo needs them."

❖ ❖ ❖

As you approach Turfan, still more legends reach you. The ancient Buddhist cave-temples, the subterranean dwellings and passages, and even the old underground irrigation canals, all this gives an unusual appearance to the place. And everything directs your thought to the same concept of distant holy countries where wise folk dwell, anxious to serve humanity. As they relate:

"From a cave came a stranger—very tall and in strange

attire. He came to the bazaar in Turfan in order to buy some things; and, in exchange, he gave a gold coin. Afterwards, when we looked at this coin more closely, we saw that such coins had been out of use for more than a thousand years. This man came from the holy land."

Or else someone says:

"Out of one of the subterranean passages came a woman, tall, serious, and of darker complexion than ourselves. She went among the people to help them. She too came from the holy land. . . ."

"Horsemen of a most unusual appearance were seen near a cave; then all disappeared. Probably they went through a subterranean passage to their own land. Through many of the passages one can actually go on horseback."

How many of these unknown riders there are—messengers!

Nearing Zaisan, our Kalmuk lama, pointing southwest to the shimmering snow-covered mountains, said, "Over there is our sacred Mount Sawur. From its summit one can see the mountains of the Sacred Land on clear days. Under the mountain is the city of Ayushi Khan, covered by sand. One can still see the walls, temples, and suburgans."

The mountain ranges from Chuguchak to the Altai grow ever wilder. It is strange to see the Oirots, a Finno-Turkish tribe, secluded in the Altai mountains. Only recently, this country, with its beautiful forests, thundering streams, and snow-white summits, began to be called Oirotia, land of the Blessed Oirot—the national hero of this secluded tribe.

A remarkable incident occurred in this country where crude forms of shamanism and sorcery were formerly practiced. About fifteen years ago, a young Oirot girl had a vision: The Blessed Oirot appeared to her as a mighty rider on a white

steed and told her that he was the Messenger of the White Burkhan, whose advent was near.

The girl received from the Blessed One many commands on how to introduce righteous customs into the country and how to address the White Burkhan who would establish a new, happy era on earth. The girl summoned the entire clan together and proclaimed to them the new Teaching, bidding them destroy their pagan altars and pray to the merciful White Burkhan. On the mountain summit was founded a cult. The people gathered together, burned juniper, and sang their newly composed songs, so elevating and touching. Upon the peaks of Mount Cherem they addressed the White Burkhan:

> *Thou who dwellest behind white clouds*
> *Behind the blue skies—*
> *Three Kurbustans!*
> *Thou, wearing four braids—*
> *White Burkhan!*
> *Thou, Spirit of Altai—*
> *White Burkhan!*
>
> *Thou, settling a nation within thyself*
> *In gold and in silver, White Altai!*
> *Thou who illuminest the day—*
> *Sun—Burkhan!*
> *Thou who illuminest the night—*
> *Moon—Burkhan!*
>
> *Let my call be inscribed*
> *In the sacred book Sudur!*

The local government became perturbed at this new religion, as they called it. And the peaceful followers of the White

Burkhan were even persecuted. But the Blessed Oirot still rides over the Altai mountains and belief in the White Burkhan is growing. Through the scattered yurtas a legend is whispered, that on the Katun River the last battle of humanity will take place and that behind a distant white mountain the shining light of the White Burkhan can already be seen. As they speak, the heads of the narrators turn to the south of the Altai to where, far off, rise the highest mountains, brilliant in their snowy adornment. These events happened among the Oirot tribe of the Altai mountains.

In the same mountains another remarkable event connected with Shambhala and the New Era took place. In that mountain district live many so-called Old Believers. Centuries ago, they fled into the dense forests, attempting to escape the persecutions against them which started in the seventeenth century during Patriarch Nikon's time and continued with especial severity after the time of Peter the Great.

The old faith is strictly observed there even now. They have their own icons. They have their own priests. They use special expressions in their prayers. Even now, everything that occurs in Siberia only slightly affects this remote people.

In the middle of the nineteenth century a strange message was brought to the Altai Old Believers from somewhere:

"In distant lands, beyond the great lakes, beyond the highest mountains, is a sacred place where all truth flourishes. There one may find the supreme knowledge and the future salvation of mankind. And this place is called Belovodye, meaning the white waters."

In secret scriptures the road to this place is outlined.

The geographical landmarks around this place are purposely misspelt in order to conceal them or else they are incorrectly pronounced. But despite the faulty spelling, you can

distinguish the correct geographical direction and this—to your surprise—again leads you to the Himalayas.

A serious grey-bearded Old Believer, if he becomes your friend, will say to you:

"From here, you go between the Irtysh and Argun rivers. After a hard journey, if you do not lose your way, you come to the salt lakes. They are very dangerous! Many people have already perished on them. But if you choose the right time, you will be able to traverse these dangerous marshes. Then you arrive at the Bogogorsh mountains, and set off along a still more dangerous path to Kokushi. After that, take the path over the Ergor itself and follow it up to the snowy land. There, in the highest mountains, is a sacred valley. This is Belovodye. If your spirit is ready to reach this place through all dangers, the people of Belovodye will greet you. And if they find you worthy, perhaps they will even permit you to remain with them. But this happens very seldom. Many people have tried to reach Belovodye. Our grandfathers, Atamanov and Artamonov went. They disappeared for three years and reached the sacred place, but they were not allowed to stay there and had to come back. They told of many wonders regarding this valley, but of still other wonders they were not permitted to speak."

When you realize which geographical names are mentioned, after correctly spelling Irtysh and Argun, you understand that the salt lakes are the lakes of Tsaidam with their dangerous passes. Bogogorsh or Bogogorye is the mountain range Burkhan Buddha. It is easy to understand that Kokushi is the range Kokushili. And Ergor, the highest upland, is the cold Chantung near the Trans-Himalayas, already in view of the Eternal Snows.

This Teaching of Belovodye is still so strong in the Altai mountains that only six years ago, a party of Old Believers

started out for this sacred place. Up to now they have not returned, but when we passed through the Altai in 1926, a letter was received through a native Oirot from a woman member of this party. She had written to her relatives that they had not yet reached the sacred place. But they still hoped to reach it. She could not say where they were living at the moment, but they were living well. Once again, legend and fairy tale are interwoven with reality. These people know of Belovodye—Shambhala—and they whisper of the path to the Himalayas.

When we crossed the Altai, several village schoolmasters came to us, asking in a whisper, "Have you come from India? Tell us what you know of the Mahatmas."

And their eyes glowed with eagerness, and they seized on each hint from the Teachings of the Mahatmas. And they whispered: "There are many of us and we exist solely by this Teaching"—in rocky mountains and in deep forests.

On the eve of our departure from the Altai for Mongolia, I heard a chant sung by a grey-bearded Old Believer, as follows:

"Oh, receive me and accept me, thou silent desert."

"How can I receive Thee, a Prince? I have no palaces and royal chambers to house Thee."

"But I need no palaces and royal chambers!"

And a little boy on the mountain sings:

> *Oh, My Beloved Master!*
> *Why so soon hast Thou left me?*
> *Thou hast left me an orphan,*
> *Grieving through all my days!*

Oh, thou desert, thou beautiful!
Accept me in thy embrace,
Into my chosen palace,
Peaceful and silent.

As from a serpent, I flee
From earthly fame and splendor,
From wealth and resplendent mansions—
My desert beloved, accept me!

I shall go to thy meadows
To rejoice at many wondrous flowers,
There to live out my years,
Until the end of my days.

I recognized the old chant about Iosaph, the son of the King. It was an old religious song about Buddha, about the life of the Lord, called "The Life of Iosaph—the son of the King of India." Iosaph (Iosaphat) is really the word Bodhisattva in an Arabic pronunciation.

And so once again, in remote mountains, subjects which lie far apart are united in dignified peaceful understanding.

A peculiar story is told of how a very old monk, who had long ago traveled in India and in the Himalayas, had recently died in Kostroma. A manuscript was found among his possessions with much material about the Mahatmas, indicating that this monk was intimately acquainted with this usually secret subject. In this way, unexpectedly, personal experiences and authentic indications are scattered abroad.

To return to the old man mentioned earlier: He leads us to a stony hill and, solemnly pointing at the stone circles of ancient tombs, says: "Here the Chud went under the earth. When

the White Tsar came to the Altai and when the white birch tree began to bloom in our region, the Chud were unwilling to remain under the White Tsar. They went underground and closed the passage with mighty stones. There you can see it. But the Chud did not leave forever. A New Era of happiness will come when the people from Belovodye will return and will give to the people the supreme knowledge; then the Chud will return with all their acquired treasures."

In Buryatia and in Mongolia we were not surprised to find many signs of Shambhala. In these countries psychic powers are highly developed. When we approached Ulan-Bator, the capital of Mongolia, we had to pass one night on the banks of the Iro. In the evening, across the river we noticed a fire. We asked what it was and received quite an unusual answer: "There is a big monastery there and just now it is the subject of wide-spread rumors throughout Mongolia. Last year near this monastery a wonderful child was born. When he was one year old, he pronounced clearly in Mongolian an important proph-ecy about the future. He never spoke again after that but grew into a perfectly ordinary child."

Again a message about the future!

When we entered Ulan-Bator, we saw an open place near a temple surrounded by a stockade, as is usual for Mongolian dwellings.

"What is this?" we asked.

Again came a surprising reply: "This is the site for a temple of Shambhala. An unknown lama came and purchased this place for a future building."

In Mongolia not only do many learned lamas know about Shambhala, but even laymen and members of the government tell you the most striking details.

When we showed some of the prophecies about Shambhala

to a member of the Mongolian government, he exclaimed in deep surprise: "But this is the prophecy that was made by the boy on the Iro River. Verily the Great Time is coming!"

And he told us how a young Mongolian lama in the region of Uliasutai had quite recently written a new book about Shambhala, explaining the exalted meaning of Shambhala for the future and speaking about the path to this wonderful place.

Another highly intelligent Buryat, one of the Mongolian leaders, told us how a Buryat lama reached Shambhala after many difficulties and remained there a short time. In the account of his unusual travels are some strikingly realistic details. It seems that when this lama and his guide reached the very frontier of the sacred valley, they saw nearby a caravan of yaks carrying salt. They were regular Tibetan merchants and, without knowing anything about it, they passed quite near the wonderful site. Even the air round this place is so strongly psychologized that people cannot see anything that should not be seen.

Another detail is striking: As this lama, returning from Shambhala, passed along a very narrow subterranean passage, he met two men carrying, with the utmost difficulty, a thoroughbred sheep needed for some scientific experiments being performed in this remarkable valley.

In the streets of Ulan-Bator one may meet a cavalry detachment of Mongolian troops, singing a ringing song with especially deep emotion.

"What song is it?" we ask.

"It is a song about Shambhala!"

And they tell us how Sukhe-Bator, the national hero of Mongolia and a leader in the recent movement for freedom, composed this song about Shambhala, and how it is now sung in all corners of Khalkha.

It begins:

Chang Shambalin Dayin,
The War of Northern Shambhala!
Let us die in this war
To be reborn again
As Knights of the Ruler of Shambhala!

Thus the latest movement in Mongolia is also combined with the name of Shambhala. And new banners are raised in honor of Shambhala.

We visited a special temple dedicated to Maitreya and another temple of Kalachakra. There we saw an unusual tanka showing the imaginary site of Shambhala.

When I presented my painting representing Rigden Djapo, the Ruler of Shambhala, to the Mongolian government, it was accepted with marked emotion; and a member of the government told me that they wished to build a special memorial temple in which this painting would occupy the central altar.

One of the members of the government said to me:

"May I ask you how you knew of the vision which one of our most revered lamas had several months ago?

"The lama saw a great crowd of people of many nations; all of them were looking towards the West. Then, in the sky there appeared a giant rider on a fiery steed, encircled by flames, with the banner of Shambhala in his hand—the Blessed Rigden Djapo Himself. And He Himself bade the crowd turn from the West to the East. In the description of the lama the majestic rider looked exactly as on your painting."

Such coincidences as the painting and also the prophecies on the Iro River provoked the exclamation:

"Verily the time of Shambhala has come!"

Many other similar wonders were related to us by edu-

cated Buryats and Mongols. They spoke about a mysterious light which shines above the Khotan stupa; about the coming reappearance of the lost Chalice of Buddha. They also spoke of the miraculous stone from a distant star which appears in different localities before the Great Advent. The Great Timur, it is said, temporarily possessed this stone. The stone is usually brought unexpectedly by strangers. In the same way, at times it has disappeared, to be rediscovered some time later in an entirely different country. The greater portion of this stone remains in Shambhala, while part of it circulates throughout the earth, retaining its magnetic link with the main Stone.

Endless stories are told about this Stone. King Solomon and the Emperor Akbar are also said to have possessed it. These sagas involuntarily remind one of the Lapis Exilis, celebrated by the famous Meistersinger Wolfram von Eschenbach, who ends his song with the line:

"Und dieser Stein ist Gral genannt!" ("And this stone is named the Grail!")

In Ulan-Bator we also heard from several sources about the visit of the Great Mahatma Himself, the Blessed Rigden Djapo, to two of the oldest Mongolian monasteries; one, Erdeni-Dzu on the Orkhon River, and the other Narabanchi.

Of the visit of the Mahatmas to Narabanchi we had already read in literature. But we were glad to see that the same details were recounted by the lamas in remote Mongolia. We were told how one night, about midnight, a group of riders approached the gates of Narabanchi Gompa. They had apparently come from a distance. Their faces were concealed by fur hats. Their Leader entered the Gompa and at once all the lamps lit by themselves. Then he ordered that all the gelongs and havarags of the monastery be called together. Approaching the Bogdogegen's seat, he uncovered his face and everyone

present recognized the Blessed One Himself. He pronounced prophecies of the future, after which all mounted their horses and departed as speedily as they had come.

We heard another story about the arrival of the Mahatma of the Himalayas to Mongolia told to us by a member of the Mongolian Scientific Committee.

As you know, we have several lamas with great spiritual powers. Naturally, they do not live in cities or big monasteries but usually in remote khutons in mountain retreats. About fifty or sixty years ago, one of these lamas was entrusted with a mission. He was to carry it out alone, but before his death he was to entrust it to one person of his own choice. You know that the greatest missions are assigned from Shambhala, but on earth they must be carried out by human hands under earthly conditions. You must also know that these missions are often executed in spite of the greatest difficulties which must be overcome by spiritual power and devotion. It happened that this lama had partly fulfilled his mission when he became ill and lost consciousness; in this state he was unable to pass on the entrusted mission to a fitting successor. The Great Mahatmas of the Himalayas knew of his difficulty. In order that the mission should under no circumstances be given up, one of the Mahatmas undertook at great speed the long journey from the Tibetan uplands to the Mongolian plains. So great was the haste that the Mahatma remained in the saddle for sixty hours and thus arrived in time.

He temporarily cured the lama, who was then able to pass on his mission in a fitting manner.

You see thus how the Mahatmas help humanity, what self-sacrifice and earthly difficulties they assume to save the Cause of the Great Coming!

In this account of the hurried journey to Mongolia, of sixty

hours in the saddle, we recognized that very story, the beginning of which we had heard in India.

In Mongolia, they called the Mahatmas the "Great Keepers" and they did not know which of the Mahatmas had undertaken this journey, but in India they could not tell us exactly for what reason the journey had been undertaken.

Such are the different threads of Asia. Who carries the news? By what secret passageways do the unknown messengers travel? Amidst the ordinary routine of daily life in Asia, confronted with difficulties, crudeness, and many trying cares, one may never be certain that, at that same moment, someone may not be knocking at your very door with important news. Two roads of life are evident in Asia; hence one should not be distressed by the visages of daily life. You may easily be faced with the Great Truth that will enfold you forever.

Camel bells sound. Long marches through the desert.

Through the air rings again the song of Shambhala. Here are stony mountain passes and frozen uplands, but never are you left without signs of Shambhala.

Our lamas bend over a stony slope. They have collected pieces of white quartz from nearby rocks and now they are carefully designing something from these white stones.

What do these complicated designs mean? No, it is not a design—it is the monogram of Kalachakra. Henceforth, this white inscription invoking the Great Teaching will be visible from afar to all travelers.

On the heights of Sharagol near Ulan Daban, on the site where the Mahatma rested on his way to Mongolia, a Suburgan of Shambhala is being constructed. All our lamas and we

ourselves carry stones and cement them together with clay and grass. The top of the suburgan is made of wood covered with tin from gasoline cans. My colors are used for decorating it. Lime for it is brought from the Humboldt mountains. The suburgan shines brightly in the purple of the desert. The Buryat lama paints many images and ornamentations on it in red, yellow, and green. Local Mongols bring their modest gifts to the Norbu Rinpoche—turquoise, corals, and beads to lay inside the suburgan. The high priest of Tsaidam himself comes to consecrate the suburgan. The Mongols give their promise to guard this monument of Shambhala—if only the Chinese Dungans or passing camels do not destroy it! Behind the suburgan the American flag waves. . . .

A day of Shambhala. A festival. There are many Mongolian guests. In front of the tent of Shambhala the lamas celebrate the Blessed Rigden Djapo. Before the painted Image of the Ruler, a polished mirror is placed. From an ornamented vessel, they pour water on the surface of the mirror. The water flows over the surface of the mirror and covers it with strange designs. The surface moves, as if living. This is a symbol of the magic mirror, where the future is revealed and where revelations are inscribed.

A lama, the guide of the caravan, binds his mouth and nose with a scarf. One wonders why, as the day is not cold. He explains: "Now precautions are needed. We are approaching the forbidden lands of Shambhala. We will soon encounter 'Sur,' the poisonous gas that guards the frontier of Shambhala."

Our Tibetan, Konchok, comes riding up to us and says in a lowered voice: "Not far from here, when the Dalai Lama went from Tibet to Mongolia, all the people and all the animals

in the caravan began to tremble. And the Dalai Lama explained that they should not be afraid: They had touched the forbidden zone of Shambhala and the aerial vibrations were unfamiliar to them."

From the Kumbum monastery, a high lama came to visit us with his ornamented tent and colorful attendants. He gave us the sign of Shambhala and told us that some Chinese had recently asked the Tashi Lama to give them passports to Shambhala. Only the Tashi Lama can do this. And just now, the Tashi Lama in China has published a new prayer addressed to Shambhala. Now everything can be reached only through Shambhala.

Again barren rocks, the endless desert. No travelers. No animals. . . .

We look at one another, amazed, for we all sense simultaneously a strong perfume, as of the best incenses of India. Where does it come from? Are we not surrounded by barren rocks? The lama whispers: "Do you feel the fragrance of Shambhala?"

A sunny, unclouded morning—the blue sky is brilliant. Over our camp flies a huge, dark vulture. We and our Mongols watch it. Suddenly one of the Buryat lamas points into the blue sky: "What is that? A white balloon? An airplane?"

We notice something shiny, flying very high, from the northeast to the south. We bring three pairs of powerful field glasses from the tents and watch the huge spheroid body shining against the sun, clearly visible against the blue sky and moving very fast. Afterwards we see that it changes direction sharply from south to southwest and disappears behind the snow-peaked Humboldt chain. The whole camp follows the unusual apparition, and the lamas whisper: "The Sign of Shambhala!"

On the grey background of the hilly desert something white is shining. What can it be? Is it a huge tent? Is is snow? But there can be no snow now in the desert. Besides, this white spot is too big for a tent. And why is it so distinct from its surroundings? We approach. As we come nearer, it appears larger than we expected. It is a huge pyramid formed by the drippings of a large geyser of Glauber salt—a real fortune for the druggist. An icy cold salt spring flows underneath this huge white mass. A lama whispers: "This is the sign of the third frontier of Shambhala!"

Approaching the Brahmaputra you can find more indications and legends about Shambhala. A further circumstance impresses one even more convincingly. In these regions in the direction of Mount Everest lived the seer, the hermit Milarepa.

Near Shigatse, on the picturesque banks of the Brahmaputra and further, in the direction of the sacred lake Manosaravar, several ashrams of the Mahatmas of the Himalayas still existed quite recently. When you know this, when you know the facts surrounding these remarkable sites, you are filled with a special emotion. Old people are still living who remember personal meetings with the Mahatmas. They call them Asaras and Khuthumpas. Some of the inhabitants remember that here there was—as they call it—a religious school founded by the Mahatmas of India. In the courtyard of this Gompa occurred the episode of the letter that was destroyed and miraculously restored by a Master. They stayed in these caves. They crossed these rivers. And in these jungles of Sikkim stood Their outwardly modest Ashram. To outsiders who have not been in these places personally, this question of the Mahatmas cannot seem materially possible.

But traversing the Trans-Himalayas you discover that

there is not one mountain range, but a whole mountain country with a peculiarly complicated design of ranges, valleys, and streams. At every step, you are convinced that existing maps are only relatively correct. Because of their complexity, these regions have still not been fully explored. The hermit, hidden in a cave, the dweller in a remote valley, may rest undisturbed.

Having personally wandered through these labyrinths, you are aware of hidden places, accessible only through some happy "chance."

Old volcanoes, geysers, hot springs, and the presence of radioactivity offer unsuspected, happy discoveries. Often, next to a glacier you can see rich vegetation in a neighboring valley apparently nourished by a hot spring. In the barren uplands of Dungbure we saw boiling springs and next to them, magnificent vegetation. Strawberries, hyacinths, and many other flowers were in bloom. There are several such valleys in the Trans-Himalayas.

During our long stay in Nagchu, local people told us that to the north of the Dangra-Yumtso Lake, among the open stony uplands, some sixteen thousand feet high there is a fertile valley yielding regular crops. In some courtyards near Lhasa, hot springs may be found which supply an entire household.

Having traveled through these unusual uplands of Tibet with their peculiar magnetic currents and electric phenomena, having listened to witnesses and having also witnessed many things, one feels one knows a great deal about the Mahatmas.

I do not wish to persuade anybody of the existence of the Mahatmas. A great many people have seen Them, have talked to Them, have received letters and material objects from Them.

If someone asks in ignorance, "But, is it not a myth?" advise them to study the book by Professor Zelinsky of Warsaw University on the reality of the origin of the Greek myths.

However, generally speaking, do not try to convince people. Real knowledge will enter only open doors. If prejudice exists, it must be outgrown through inner development.

For us it is important to prove, by the existing facts, what immense distances one living consciousness covers and how strongly it is open, ready for the future evolution.

In the entire East, the deep veneration for the Teacher has surrounded the concept of the Guru with a sacred solicitude and impregnability. The concept of the Guru-Teacher is understood with such veneration only in the East.

Let me remind you of the legend from "Agni Yoga" about the small Hindu boy who had found his Teacher:

"We asked him: 'Is it possible that the sun would darken for you if you were to see it without the Teacher?'

"The boy smiled: 'The Sun would remain the same, but in the presence of the Teacher, twelve suns would shine for me.'

"The sun of wisdom of India shall shine because upon the shores of a river there sits a boy who knows the Teacher.

"There are conductors of electricity, and also there are unifiers of knowledge. If a barbarian should make an attempt against the Teacher, tell him how humanity named the destroyers of libraries."

The foundations of the East are fortified by the concept of the Guru. What wonderful words and dignified gestures can be found in India with regard to the Teacher!

Many Hindu, Chinese, and Japanese scholars know many things about the Mahatmas. But reverence before the Master, which is so characteristic of the East, prevents them from

showing this knowledge to the uninitiate. The sacred meaning of the word Guru, the Teacher and Spiritual Guide, makes the subject of the Mahatmas almost unapproachable throughout Asia. Thus, it is quite easy to understand why many have passed through Asia without meeting this question. Either ignorance of the languages or divergent interests or bad luck in not meeting the right people prevented them from seeing the idea of the most precious. You know how very often we visit museums or temples, but without special permission we cannot examine the sacristy and the hidden storerooms of museums where sometimes the most precious things are preserved.

In the East, one finds many stories about people who disappeared; and some of these stories are connected with the concept of Shambhala. I could even tell you the name of a member of the geographical society who visited India in the 1860s. He came back, appeared again once at an official court reception, and then returned to the East. Since then, nothing has been heard of him, but evidence was given to us that he is still alive, living under quite unusual conditions.

One can mention many people still living who have personally met Mahatmas. This has happened as often in India as in England, France, America, and other countries.

As we followed the banks of the Brahmaputra, we remembered how a Tibetan representative in Ulan-Bator advised us to visit an unusual hermit of untold age who lived in a mountain retreat, as he called it, several days' journey west of Lhasa. The Tibetan insisted that the hermit was most extraordinary for he was not a Tibetan but, according to what was said of him, a Westerner.

And we remembered again how a respected inhabitant of Sikkim told us of a strange hermit living north of Kanchenjunga.

❖ ❖ ❖

The circle is nearing completion. Again, we are in Sikkim.
Again, the splendor of the Himalayas is behind us to the north.

All eyes are attracted to the majestic white summits rising
above the clouds. They tower, like a transcendental realm.
From all sides, the best aspirations are directed to the Himalayas.

Kang-chen-dzod-nga—Five Treasures of Great Snows.
And why is this sublime mountain so called? Because it con-
tains a store of the five most precious things in the world. What
things are there—gold, diamonds, rubies? By no means. The
old East values other treasures. It is said that there will come
a time when famine will overcome the whole world. At that
time a man will appear who will unlock the giant gate of these
vast treasuries and nurture all mankind. Certainly you under-
stand that this man will nourish humanity not physically, but
with spiritual food.

On ascending the Himalayas, you are greeted by the name
of Shambhala. On descending, the same great concept blesses
you. Shambhala will nourish humanity with spiritual food
attained by mastering the cosmic energies.

Good news awaits us in Sikkim: During our absence, our
friend, Rinpoche of Chumbi, has built two more monasteries,
and everywhere the images of Maitreya and Shambhala are in
places of honor.

Our lama artist Lariva is still at Ghum and has painted a
wall fresco, a mandala of Shambhala, in which is depicted, in
a symbolic stylization, the secret valley surrounded with snowy
peaks. The Ruler, Rigden Djapo, is the central figure.

During these years, Geshe Rinpoche has begun to speak
more openly of Shambhala. In a symbolic form he tells of the
power of the epoch of Shambhala.

Rinpoche presented to us a recent Tibetan book dedicated to Shambhala. In this book are collected the prayers to Shambhala, given by Panchen Rinpoche, the Tashi Lama, during his last travels. From this collection you can see that the Spiritual Ruler of Tibet issued a special prayer to Shambhala in every place where he stopped on his journey. This is remarkable.

And then came a ring with the seal of Shambhala.

A grey-haired, revered Gur from the Kulu Valley told us: "In the Northern Land—in Utturkan—on the high uplands, live the great Gurus. Ordinary people cannot reach this land. The Gurus Themselves do not leave the heights at present— They do not like the Kali Yuga. But in case of need They send Their pupils—Chelas—to warn the Rulers of nations." In this way, in the ancient sites of Kulu, the knowledge of the Mahatmas is crystallized.

Before me are six paintings representing Shambhala:

The most esoteric is a mandala of Shambhala in which one may recognize suggestions of reality. At the top is the Yidam, as a sign of elemental force, and the Tashi Lama who wrote the very secret book, *The Path to Shambhala*. In the middle, the snowy mountains form a circle. Three white borders can be distinguished. In the center appears to be a valley with many buildings. One can see two apparent clefts, like the plans of towers. On the tower is He Himself, whose light glows at the predestined time. Below, a mighty army conducts a victorious battle and Rigden Djapo Himself is Commander. It is the victory of the spirit on the great battlefield of life. This is a new representation of Geshe from Tashi-Lhunpo.

On the lower part of another painting, a victorious battle is also depicted. In the middle is Rigden Djapo Himself giving commands. In front of the Ruler are all the lucky signs and

treasures predestined for mankind. Behind the Ruler is a palace and on either side are his father and mother. And above is Buddha. This is a new representation from Sikkim.

The third painting does not show a battle—it is a triumphant one with many ornamentations in gold. In the center is a large figure: Rigden Djapo giving His blessing. In front of him, in golden relief, shines the Akdorje, the crossed lightning. Below are the treasures. At the top is the Lord Buddha, and to the right and left are two Tashi Lamas, the third and the present. In this latter affirmation is expressed the thought of today. This is a representation from Ghum.

In the fourth painting, one sees many warriors on horseback and on foot, commanders and advisers, gathered round Rigden Djapo. The painting is from Nagchu.

The fifth painting, from Tashi-Lhunpo, show Rigden Djapo teaching several Gurus the commandments of wisdom.

The sixth ancient painting, brought from Tashi-Lhunpo by a lama-refugee, shows Rigden Djapo in the center. The back of the Ruler's throne is in the form of blue wings surrounded by flowers. In his left hand he holds the wheel of law, and with the right he calls on the earth as his witness. Below have gathered all the nations of Asia. By their dress one can distinguish Hindus, Chinese, Moslems, Ladakhis, Kalmuks, Mongols, Tibetans. Everyone carries his treasures: one has books, another arms, another flowers. In the middle is the great treasure. The battle is over. The nations have been called to prosperity.

Now let us summarize these scattered indications about Shambhala: The Teaching of Shambhala is a true Teaching of Life. As in Hindu Yogas, this Teaching indicates the use of the

finest energies which fill the macrocosm and which are as powerfully manifested in our microcosm.

Therefore, are the Asaras and Khuthumpas related to Shambhala? Yes.

And the Great Mahatmas and Rishis? Yes.

And the Warriors of Rigden Djapo? Yes.

And the whole cycle of Gesar Khan? Yes.

And, of course, Kalachakra? Yes.

And Aryavarsha, from where the Kalki Avatar is expected? Yes.

And Agharti with its subterranean cities? Yes.

And Ming-ste? And the Great Yarkhas? And the Great Dwellers of Mongolia? And the inhabitants of Kalapa? And the White Island? And the Grail—Lapis Exilis? And the Belovodye of the Altai? And Chud, the subterranean people? And the underground passages of Turfan? And the hidden cities of Cherchen? And the submerged Kitesh? And the Suburgan of Khotan? And the White Mountain? And the sacred valley of Buddha's Initiation? And Agni Yoga? And Dejung? And the book of Wu-tai-shan? And the Tashi Lamas? And the Place of the Three Secrets? And the White Burkhan?

Yes! Yes! Yes! All these have assembled round the Great Name of Shambhala in the conception of many nations and many ages. There is also the whole mass of isolated facts and indications, deeply felt in spirit even if not explicit.

Esoteric Buddhism penetrated into Tibet in the seventh century A.D., but esoteric Buddhists had their strongholds there already before our era, on the slopes of Kailas and in Northern Punjab, possibly in the environs of Kulu. Although science regards Atisha as the propagator of this doctrine, the essential Teaching of Shambhala existed, of course, much earlier, its origin hidden in the centuries.

Shambhala, or the White Island, is indicated as being to the west of Himavat. One must respect the caution with which the approximate locality of this remarkable sanctuary is divulged.

Bhante-Yul and Dejung are also synonyms for the White Island.

To the north of Kailas, towards Kun-Lun and Cherchen, was the so-called Aryavarsha from where the Kalki Avatar is expected.

"The Place of the Three Secrets," "The Valley of the Initiation of Buddha"—these indications lead the consciousness of the people in the same direction, beyond the white ranges of the Himalayas.

Shambhala itself is the Holy Place where the earthly world links with the highest states of consciousness. In the East they know that there exist two Shambhalas—an earthly one and an invisible one. Many speculations have been made about the location of the earthly Shambhala. Certain indications put this place in the extreme north, explaining that the rays of the Aurora Borealis are the rays of the invisible Shambhala. This attribution to the north is easily understood—in Tibet, the ancient name of Shambhala is Chang-Shambhala, and this means Northern Shambhala. The origin of this name is explained as follows: The Teaching was originally manifested in India where everything emanating from beyond the Himalayas is naturally north. North of Benares is a village, Shambhala, connected with the legend of Maitreya. Hence, it is apparent why the Trans-Himalayan Shambhala is called Northern Shambhala.

Several indications, blended in symbols, place Shambhala in the Pamirs in Turkestan or in the Central Gobi. Wessel in his *Jesuit Travelers in Central Asia* refers to the Jesuit, Casella, who died in 1650 in Shigatse. The proposal was made

to Casella, who enjoyed the most intimate relations with Tibetans, to visit the land of Shambhala.

The many misconceptions about the geographical location of Shambhala have natural reasons. In all books on Shambhala, as well as in all the narrated legends about it, its location is described in highly symbolic language, almost indecipherable to the uninitiate.

Take, for instance, the translation by Professor Grünwedel of *The Path to Shambhala*, the famous book written by the Third Tashi Lama. One is overwhelmed by the number of geographical indications, so blended and mixed, that only great knowledge of old Buddhist places and of local names can assist in disentangling its complicated web.

You will easily understand why such a veil was needed. One of the Mahatmas was asked why They hide Their Ashrams so carefully. The Mahatma answered: "Otherwise an endless procession from West and East, North and South would overflow our remote places, where now, without permission, nobody may disturb our studies."

And it is really so. Here, in the turmoil of the city, it is hard to imagine how many people are searching for the Teaching of the Mahatmas.

A learned lama, whose name is known in the West, told us about the numberless inquiries and letters he was receiving from France, England, America, asking his advice on how to come into contact with Mahatmas and how to receive Their Teaching. Reality and the loftiest attainments once more come together.

Not a mere Messianic Creed but a New Era of mighty energies and possibilities is expressed in the term Shambhala.

Now, when each day we are overwhelmed by the discoveries of physics, by the power of oxygen, or by the reality of

the Great Fire of Space, when from the summits is proclaimed the teaching of Agni Yoga, then we can in full sincerity approach our friends in Asia in the Name of the coming Shambhala. And with a happy smile we can greet the Great Future of Mighty Energies! The last call of our evolution is the imperative call for creative action, for enlightened labor, for achievements here on earth, without delay.

Our friends, the Vedantists, have pointed out that the epoch of Shambhala, unlike previous epochs, which have been characterized by gradual evolution, will be attended by a great evolutionary momentum.

The Vedic traditions say that the time is near, when new energies—mostly Agni energies, energies of cosmic fire—will approach the earth and will create many new conditions of life. The date for the first approach of these energies is calculated in the forties of our century. The Brahmacharyas of the Sri Ramakrishna and the Swami Vivekananda Ashrams, confirmed this date to us as well as the whole tradition.

The Teaching of Life by the Mahatmas of the Himalayas speaks definitely of it.

Agni Yoga, in full coordinance with the latest problems of science, points the way for research into the elements and the subtlest energies. What only recently was commonly known as the teaching of willpower and concentration, has now been evolved by Agni Yoga into a system of mastering the energies which surround us. Through an expansion of consciousness and a training of spirit and body, without isolating ourselves from the conditions of the present day, this synthetic Yoga builds a happy future for humanity.

Agni Yoga teaches: "Do not leave life; develop the faculties of your apparatus and understand the great meaning of

psychic energy—human thought and consciousness—as the greatest creative factors."

The Yoga teaches: "With self-responsibility and in conscious cooperation, let us strive towards the predestined evolution. But, for this we must first understand the joy of labor, of incessant courage, and of responsibility, realizing all our possibilities."

Referring in most practical formulae to all the different sides of life, Agni Yoga reveals to us how near the elements are and that most all-penetrating of them—Fire.

Agni Yoga separates reality from maya. Agni Yoga revolts against "wonders," bringing phenomena or manifestations into the realm of positive knowledge.

"One must learn the organization of psychic energy," Agni Yoga affirms.

This Yoga affirms boldly: "Let us be sincere, and discard all prejudices and superstitions that are not fitting to the conscious man who wishes to investigate and to acquire knowledge scientifically."

Speaking of the approaching influence of cosmic energies, the Yoga warns of the peculiarities of the immediate future. The Yoga addresses physicians as follows:

During the development of the centers, humanity will feel incomprehensible symptoms which science, in ignorance, will attribute to the most unrelated ailments. Therefore, the time has come to write the book of observations regarding the fires of life. I advise against delay because it is necessary to explain to the world the manifestations of the reality and unity of existence. Imperceptibly, new combinations of perception enter life. These signs, visible to few, constitute the foundation of life, penetrating all its structures. Only the blind fail to per-

ceive how life is filled with new concepts. Therefore, scientists should be called upon to cast light on the evidence. Physician, do not neglect! . . .

Our Teaching strives towards the realization of the perfect manifestations of Nature, considering man as part of Nature. . . .

Obviousness prevents us from seeing inner currents. Everyone can remember how he mixed up chance with the fundamentals, formulating arbitrary concepts. The same may be said of the element of Fire. Someone may think lightmindedly: "Our grandfathers lived without knowledge of Fire and they passed peacefully into the grave. Why should I worry about Fire? ". . .

But the reflecting mind thinks, "From where did all the unexplainable epidemics that dry out the lungs, throat, and heart come? Beyond all reasons, there must still be others unforeseen by the physicians. It is not conditions of life, but something external that mows down the people." By this method of attentive observations, one may arrive at an unprejudiced conclusion.

Or Agni Yoga calls:

Agni Yoga is coming in time. Who else would say that epidemics of influenza should be cured by psychic energy? Who else would draw attention to the new forms of psychic, brain, and sleeping sickness? Leprosy, the old form of plague, cholera—these are not terrible; against them we have preventive measures. But one should think about the new enemies created by contemporary life. Old measures cannot be applied to them; a new approach will be created by the expansion of consciousness.

One can see how, over thousands of years, the waves of sicknesses flowed. From these signs one can compile a remarkable scale of human decline. Sicknesses naturally show the negative side of our existence.

Let us hope that the vital minds will think in time. It is too late to make a pump when the house is already on fire.

Agni Yoga says of psychic energy:

People have completely forgotten how to understand and apply psychic energy. They have forgotten that any energy once set into motion creates a momentum. It is almost impossible to stop this momentum; therefore every manifestation of psychic energy continues its influence by momentum, often for a long time. One may already have changed one's thought, but the effect of the previous transmission will nevertheless permeate space. In this lies the power of psychic energy as well as a quality deserving special care.

Psychic energy can be dominated only by clear consciousness so that one's way is not obstructed by previous transmissions. Often a casual and sporadic thought stirs the surface of the ocean of achievement for a long time. A man may have forgotten about his thought long ago, but it continues to fly before him, lighting or darkening his path.

To the shining ray, small lights are attracted, enriching it. To filth, dark and dusty particles adhere, hindering motion. When we say, "Fly brightly," we are warning about an action. Everything said about psychic energy refers to action. Here nothing is abstract because psychic energy is at the foundation of all nature and is expressed especially in man. Man may try to forget psychic energy, but it will always remind him of its presence. And it is the duty of education to teach mankind how to use this treasure. If the time has come to speak of the visible physical residues of psychic energy; then, consequently, reality has become evident.

This means that people must without delay strive to master psychic energy.

The Fire of Space and psychic energy are close together and are the foundation of evolution.

As an example of the vital indications of Agni Yoga, one can quote a passage about the sequence of nerve centers:

Kundalini, as the center leading into samadhi, will in our further evolution yield its place to another center near the heart. This center, called the chalice, is the seat of the manas and the center of feeling-knowledge. With the expansion of consciousness, feeling-knowledge leads to action, which is the main distinction of future evolution. The center of the third eye acts in coordination with the chalice and with kundalini. This triad characterizes in the best way the basis of the activity of the approaching epoch. Not an ecstasy that carries one away, but an affirming and creative foundation that is predestined for the future achievement of mankind.

One can quote from "Agni Yoga" many indications of utmost importance, scattered all through the Teaching, a precious mosaic:

"Have you learned to enjoy obstacles?"—what a powerful consciousness sounds through this vigilant call!

Yoga—as that supreme link to cosmic attainments—has existed through all ages. Each Teaching maintains its own Yoga, applicable to the grade of evolution. Nor do the Yogas contradict each other; they are as the branches of one tree which spread their shade and refresh the traveler exhausted from heat. His strength regained, the traveler continues on his way. He accepted naught that was not his; nor did he misdirect his striving. He embraced the manifested benevolence of Space; he liberated the preordained forces. He took control of his property.

Do not reject the forces of Yoga; but, as light, let them search the twilight of Labor unrealized. For the future, we

arise out of sleep. For the future, we renew our garments. For the future, we gather strength.

We shall hear the approach of the element of Fire, but we shall already be prepared to master the undulations of the flame.

Thus, the traveler of life is blessed by Agni Yoga, given "in the valley of the Brahmaputra, which takes its beginning from the lake of the Great Nagas, guarding the covenants of the Rig-Vedas."

Human beings have remained too long at a low material level—they must hurry to seize the brilliant possibilities long since predestined. One is amazed to remember that in 1878 Edison's phonograph was denounced by the Académie Française as the trick of a charlatan. We can still remember how the first motor cars were proclaimed impractical; how electric light was considered dangerous for the eyes and telephones bad for the ear. It is with reluctance such as this that mankind gets accustomed to new concepts. Prejudice permeates the foundation of society.

You may easily imagine the exalting sensation when, amid the white peaks of the Himalayas, you receive mail from the States. Along with much news of great importance, your friends send you the newspaper accounts of the meeting of the American Association for the Advancement of Science, in which many of the best American scientists take part. And you see how a whole series of sincere researchers arrive, through practical study, at the same conclusions as are so imperatively affirmed by Agni Yoga. Armed with age-old experience, Agni Yoga speaks about the freedom of the spreading of true knowledge. Agni Yoga proclaims the scientific foundation of the principles of existence.

And where do we find a response to this Call? Far beyond the ocean, in America, the liberated minds of scientists, unbound by prejudice, move in the same direction of reality. The summits of Asia and the heights of America clasp hands on the basis of true research and self-denying affirmation.

Millikan's cosmic ray, Einstein's relativity, Theremin's music from the ether, are all accepted by the East in a most positive way because ancient Vedic and Buddhist traditions confirm them. Thus East and West meet! Is it not beautiful if we can greet the old concepts of Asia from our modern scientific point of view? If the Shambhala of Asia has already come, let us hope that our own Shambhala of enlightened discoveries is also near.

World Unity, mutual understanding—these concepts have seemed like the dreams of an impractical optimist. But now even the optimist should be practical and the concept of world unity must advance from the notebook of the philosopher and enter real life!

If I say to you, "Let us be united," you will ask, "In what way?" You will agree with me: The easiest way to create a common, sincere language is, perhaps, in Beauty and Knowledge.

In Asia, if I speak in the name of Beauty and Knowledge, I will be asked: "What Beauty and what Knowledge?" But when I say: "In the Knowledge of Shambhala, in the splendor of Shambhala," then I will be listened to with special attention.

From my previous words you may see that in Asia the essential Teaching of Shambhala is a very vital one. Not dreams, but most practical advice, is given in this Teaching from the Himalayas. The Agni Yoga and several other books in which fragments of this Teaching of Life have been given, are very near to every strong and searching mind. Some time ago so much was

said about the opposites East and West, North and South. These were the words of separation. Actually, where is the real frontier between East and West? Why is Algeria in the East and Poland in the West? And will not California be the Far East for China?

Agni Yoga says:

> Do not divide the world by North and South, nor West and East, but distinguish everywhere between an old world and a new world. The old and the new world differ in consciousness, but not in outer appearance.

I noticed with great joy that at the meeting of the Asiatic Society of Bengal on 5 February 1929, the president of the society, Dr. Rai Upendranath Brahmacharya Bahadur, stated that "The theory that 'East is East and West is West, and never the twain shall meet' is to my mind a fossilized idea, not to be entertained."

So above all conventionalities, above all separation, some sparks of peaceful world unity can be seen. In the name of this worldwide peace, in the name of peace for all, in the name of unity of understanding, it is a great joy to pronounce here the sacred word of Asia—Shambhala.

You have noted that the concept of Shambhala corresponds to the aspirations of our most serious Western scientific research. Shambhala does not invoke the darkness of prejudice and superstition; this word should be pronounced in the most positive laboratories of true scientists. Their striving unites the Eastern disciples of Shambhala and the best minds of the West, which do not fear to look beyond outworn methods.

How precious it is to ascertain that East and West are united in the name of free knowledge.

I remember the words written by a Japanese man in the

album of a Western lady: "We will remember you at sunrise; you remember us at sunset."

But now we can write in the album of our Eastern friends:

"An inextinguishable Light is shining. In the name of beauty and of knowledge, the wall between the West and the East has vanished."

From the depths of Asia is ringing the chord of the sacred call: "Kalagiya"—"Come to Shambhala!"

INDEX

143

NICHOLAS ROERICH
THE LIFE AND ART OF
A RUSSIAN MASTER

JACQUELINE DECTER
WITH THE NICHOLAS ROERICH MUSEUM

"...outstanding serious new volume...deals not only
with dance but with world culture, and does so
brilliantly. Roerich's collaboration with Nijinsky,
Stravinsky, and Diaghilev on the 1913 'Le Sacre de
Printemps' changed the history of dance, but Decter
also tells of Roerich's world travels, his writings,
theories on education and activities as a peace-
maker that earned him a nomination for the Nobel
Prize." —**The Boston Globe**

"...vibrant colors, rich source material...Roerich's
ideas, often ahead of others,' were part of a greater
context. The virtue of this book is its clarification of
Roerich's global vision, which hoped to marry
science and art and man and the universe."
—**The New York Times**

Nicholas Roerich
The Life and Art of a Russian Master
JACQUELINE DECTER WITH THE
NICHOLAS ROERICH MUSEUM

Drawing on original Russian source material, this
lavishly illustrated art book and biography is the first
ever published in English detailing the extraordinary life
of Nicholas Roerich (1874-1947), from young artist to
mature visionary.

More than eighty paintings are featured, covering the
full scope of the artist's career, from ancient Slavic,
mythic, and archeological subjects to breathtaking
Himalayan landscapes and religious themes that span
the spiritual traditions of the world.

ISBN 0-89281-156-0
224 pages, 10 1/2 x 10 1/2
88 color plates, 35 black and white photographs
$39.95 clothbound

Available in many fine bookstores, or to order direct, send check
or money order payable to Inner Traditions, plus $2.00 shipping
for the first book, and $1.00 for each additional book to:

AIDC/Inner Traditions
64 Depot Road
Colchester, VT 05446
1-800-445-6638 (toll-free)

Be sure to request a free catalog.

Shambhala
In Search of the New Era
NICHOLAS ROERICH

With characteristic
insight, Nicholas Roerich
relates the experience
of his travels through
Central Asia and Tibet
in the 1920's, revealing
the spiritual qualities of
the people and cultures
of the region. Drawing
on his own observations
and the local legends and
parables, Roerich reveals
the many facets of the theme of *Shambhala*, a new era of
human achievement and destiny.

ISBN 0-89281-305-9
336 pages, 5 3/8 x 8 1/4
$10.95 paperback

"...*a great artist, a great scholar and writer, archaeologist
and explorer...a creative genius (who) lighted up many
aspects of human endeavor.*"
— **Jawaharlal Nehru**

"*Nicholas Roerich is one of the cultural pillars of Russia*"
— **Mikhail Gorbachev**

"*Rediscover this forgotten renaissance man whose belief
in harmonious integration of life and art led him to four
continents .*"
— **Library Journal**

Bob

1. TOOTHBRUSH
2. aqua-pick
3. COLOGNE
4. purple scarf
5. MAROON + Black scarf
6. zegna shirt red
7. zegna " green
8. " " blue
9. BROWN shirt
10. PURPLE sweater
11. INCA BATHROBE
12. LIGHT BATHROBE
13. egg cream
14. shaving case large
15. " " small
16. cufflinks silver
17. " " amber
18. " " multicolor

RUMPOLE BOOK?
CLOCK?

CHRIS

1. leather coat
2. Earing
3. BOOK - ?
4. sleepsounder
5. TIE
6. TIE
7. TIE
8. TIE
9. multicolor shirt
10. purple sweater
11. pinkinsh cotton T-NEK
12. shaving kit
13. DENIM shirt
14. Black TURTLENECK
15. Black scarf
16. gloves
17. gloves
vest?
guitar?

Tara

1) xmas jasmine
2. xmas " 22 Books
3. pig 23. CAT
4. BRACELET necklace
5. silver earing
6. solamesler earing
7. malachite "
8. garnet "
9. Laura Ashley TOP
10. petunia
11. mule jacket
12. j crew gloves+scarf
13. Beige roll
14. brownsweater
15 " sweater
16 j crew plaidshirt
17 " " " "
18 " " "
19. J crew Tneck
20 " " T eck
21 k sorler